YUN-FEI JI: THE EMPTY CITY

Published by
Contemporary Art Museum St. Louis
3750 Washington Boulevard
St. Louis, Missouri 63108
www.contemporarystl.org

This publication was prepared on the occasion of
the exhibition YUN-FEI JI: THE EMPTY CITY

Organized by Shannon Fitzgerald, curator, for
the Contemporary Art Museum St. Louis.

Contemporary Art Museum St. Louis acknowledges the
generous funding support for the exhibition and catalogue
awarded by the National Endowment for the Arts, Missouri
Arts Council, and the Regional Arts Commission St. Louis.

Additional support for YUN-FEI JI: THE EMPTY CITY has
been generously provided by Pierogi, Brooklyn, New York.

ISBN 0-9712195-3-2
Library of Congress Control Number: 2003116564

Edited by Shannon Fitzgerald
Copy edit by Kate Weigand

Photography of *The Empty City* by John Berens, New York
Installation photography by Jay Fram, St. Louis

Design by Omnivore, Alice Chung and Karen Hsu
Printed by Oddi, Reykjavik, Iceland
Printed and bound in Iceland

YUN-FEI JI: THE EMPTY CITY
Contemporary Art Museum St. Louis
January 23–March 28 2004

Pierogi, Brooklyn, New York
April 23–May 24, 2004

Provisions Library
GAEA Foundation
Washington, D.C.
June 4–August 14, 2004

The Rose Art Museum of Brandeis University
Waltham, Massachusetts
September 9–December 12, 2004

Richard E. Peeler Art Center, DePauw University
Greencastle, Indiana
February–April, 2005

4 DIRECTOR'S FOREWORD AND ACKNOWLEDGMENTS
PAUL HA

The exhibition created by Brooklyn-based artist Yun-Fei Ji for the Contemporary Art Museum St. Louis gives our audience an unprecedented opportunity to view his extremely personal works. The work reflects public issues and policies that have affected the Chinese population and recent decisions, which we can only presume will have life-altering effects on the current masses.

It is fitting that Yun-Fei's new work has found its way to St. Louis. I was introduced to his work in New York some years ago. As committed now as he was then, Yun-Fei's dedication to visually translate historical moments in China has remained his focus. I am delighted that we are able to exhibit his new works in our new building.

I would like to thank Peter Norton for loaning the important work *Bon Voyage* from the Collection of Peter Norton, Santa Monica, as it is an important introduction to *The Empty City*. Thanks to Kris Kuramitsu for her assistance with that loan. I extend my thanks to Wendy Clark and the National Endowment for the Arts for their financial support and recognition.

I would like to acknowledge Mel Watkin for originally initiating this project for the Contemporary and scheduling the exhibition on our calendar. My deep gratitude goes out to Joe Amrhein and Susan J. Swenson of Pierogi, Brooklyn, New York, for their assistance with the exhibition, its catalogue and presenting it in Brooklyn. They provided crucial partnership when needed and displayed the generosity and spirit we all desire in collaboration. Their support and dedication to this project allowed the exhibition, its catalogue, and tour possible and I thank them for the enormous contribution. I am also thankful to Joseph D. Ketner of The Rose Art Museum of Brandeis University, Donald Russell of Provisions Library, GAEA Foundation and Kaytie Johnson of the Richard E. Peeler Art Center at DePauw University for participating in the project and hosting *The Empty City* at their fine institutions.

The contributions of many individuals have enabled the Contemporary to host the exhibition *Yun-Fei Ji: The Empty City*. My heartfelt thanks go out to the entire staff of the Contemporary, especially curator Shannon

Fitzgerald who organized the exhibition, catalogue and tour and curatorial assistant Andrea Green for completing the detailed work necessary to make this exhibition and catalogue possible. Brandon Anschultz and Mike Schuh deserve recognition, as they handled the loans, installation, and travel schedule that enabled *The Empty City* to open in St. Louis and travel to New York, Washington, D.C., Waltham, Massachusetts, and Greencastle, Indiana. I thank Susan Werremeyer and her resourceful and dedicated team, Brigitte Foley and Annie Denny; these vital members of our development department continue to find new sources of support while making sure that current supporters remain interested and engaged. Lisa Lindsey's vigilance as our office manager maintains the museum in a ready state. I am thankful to Susan Lee and Kelly Scheffer for leading the army of docents, both adults and teens, and for creating an atmosphere that fosters excitement to learn and to teach. My appreciation to all our docents—the ambassadors of this institution; they can not be thanked enough for their valuable service. Thanks to Katrina Evans for maintaining the high quality of our printed and online materials and to Sarah Ursini for making sure everyone who enters the Contemporary feels welcome and appreciated. My deep gratitude goes out to the board members of the Contemporary, especially our irreplaceable president Susan Sherman, for their stewardship and championing of this institution. It is only with the board's exceptional efforts and support that we are able to open our doors to the public on a daily basis. My thanks goes out to all those who visit the Contemporary to see our exhibitions. Your participation and support allow us to foster contemporary art and to contribute to art history.

I thank Melissa Chiu, Tan Lin, and Gregory Volk for the insightful and enlightening essays that they contributed to this catalogue. Additional thanks to the design team at Omnivore, Alice Chung and Karen Hsu, for making a beautiful catalogue that is perfectly formatted to present Yun-Fei Ji's work. I also thank Kate Weigand for her meticulous copyediting. My ultimate gratitude goes out to Yun-Fei Ji for creating work that encourages discourse and exploration in contemporary thinking. Focusing on the importance of exhibiting and documenting new work, I am delighted that the Contemporary has organized his first museum exhibition.

INTRODUCTION
SHANNON FITZGERALD, CURATOR

In his first solo traveling museum exhibition, Brooklyn-based artist Yun-Fei Ji presents *The Empty City*, a new series of paintings that reflects the artist's interest in the social, political, and environmental landscape of contemporary China. This series addresses the specific histories and problematic issues surrounding the construction of the world's largest dam, the Three Gorges Dam along the Yangtze River. Created in a narrative format, Ji's series offers a looming look at the current situation in China and the havoc such a crisis will yield. Comprised of six paintings, *The Empty City* presents scenarios that compress the past, present, and future within mystic, veiled landscapes. The paintings portray the failure of modernist utopian ideas and perhaps warn of what China's future may hold. Ironically, the dam itself never appears within Ji's fantastical landscapes, which, despite the disturbingly prophetic quality of the daunting content, are extraordinarily beautiful.

Masterfully painted on *xuan* paper with mineral inks, *The Empty City* is a series of related landscapes in alternating horizontal or vertical "scroll-like" formats. Each landscape is centered on the theme of autumn — the visual centerpiece of the exhibition — and poignantly acts as a metaphor for several approaching ends: the end of a historical moment, the end of progress, the end of a life cycle. Ji's paintings reveal the effects that the construction of the Three Gorges Dam has had on the region and its inhabitants and the utter destruction that is inevitable upon its completion in 2009. His paintings portray a visionary view of what the 1.9 million forcibly displaced inhabitants of the Yangtze River region will face, while also considering the environmental impact of the dam and the danger posed to historical relics and cultural antiquities in and around the Three Gorges area.

From a distance, Ji's traditional brush paintings seem to recall the atmospheric landscapes of the Sung dynasty, but upon closer examination, the viewer quickly moves through time as Ji's mists, clouds, foliage, and mountains reveal fallen modernist buildings, abandoned villages, piled scrap yards, and broken-down vehicles. Within this toxic and dangerous environment are people from the past (who may or may not be responsible for such conditions), contemporary scavengers trying to survive on what remains, and the living dead and ghosts. All these elements and characters share the same compressed space. From within such dark imagery, stylized abstractions lifted from elements of a struggling culture saturate the composition: the cross-hatching of a woven basket, various wheel structures, stripes on shopping bags and tent shelters, and various floral and fauna designs taken from textiles. Framed by craggy mountains, voluminous hills, and swelling landscapes, a variety of indigenous plants and trees stunningly conceal and reveal dense amounts of information.

Ji employs age-old methods and traditional materials (inks, muted pigments, Chinese brushes, and handmade *xuan* paper) to illuminate historic and contemporary concerns in a packed and urgent space. By using brushes and water to alternately add ink to and subtract ink from the paper, Ji lends each painting an antiquity and precious sensibility that leaves the viewer momentarily wondering about the age of the work and its narratives.

While Ji's landscapes are influenced by his Chinese predecessors, they also depart from traditional methods in a number of ways. Ji plays with our perceptions of space and scale, giving his landscapes a surreal and disconnected quality. Instead of the spatial depth achieved by the Sung dynasty landscape painters, Ji's overloaded scenes create a nonsensical space-time relationship while projecting the picture plane into the viewer's space. The disproportionate mythical, political, and historical figures within Ji's landscapes create enigmatic and fascinating narratives for viewers to unravel. References to past historical events in China include the Opium Wars, the Boxer Rebellion, the Great Leap Forward, and the Culture Revolution. Ghosts of

8 these events and the individuals involved are characterized by Red Guard uniforms, smelting pots, white face masks, and dunce caps. The infamous are poetically juxtaposed with the unknown — the dignified nameless who are diligently engaged in the daily tasks at hand despite their foreboding future.

Yun-Fei Ji's presentation could be interpreted as a quiet and sympathetic plea for a global humanity. While *The Empty City* is about the possible fate of thousands of people in China, the series also causes one to contemplate each individual's place and position: within the past, present, and future; between nature and the man-made; and, most of all, within the globalization movements that contemporary culture claims as progress.

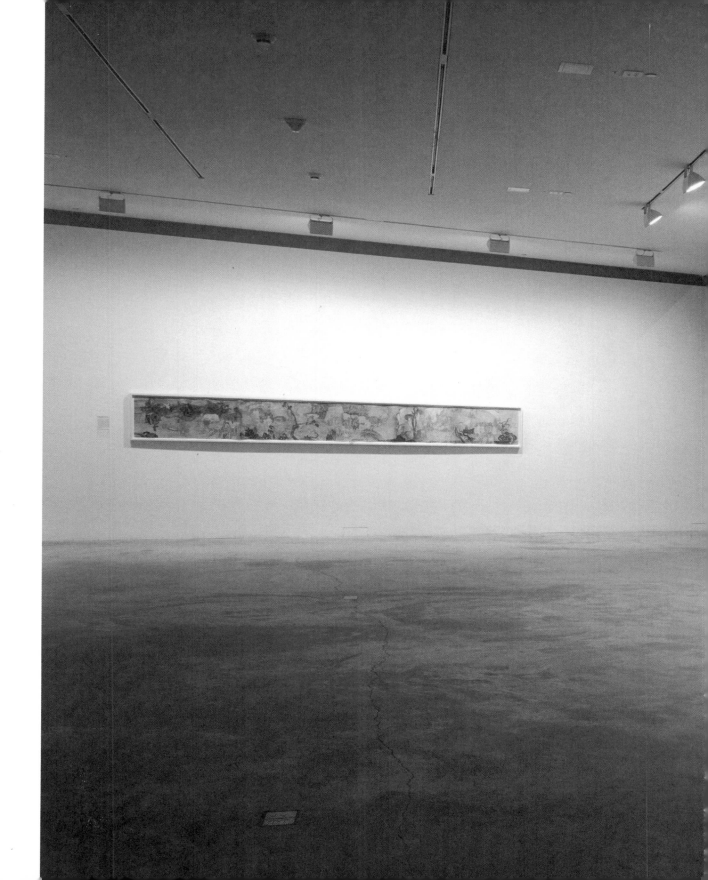

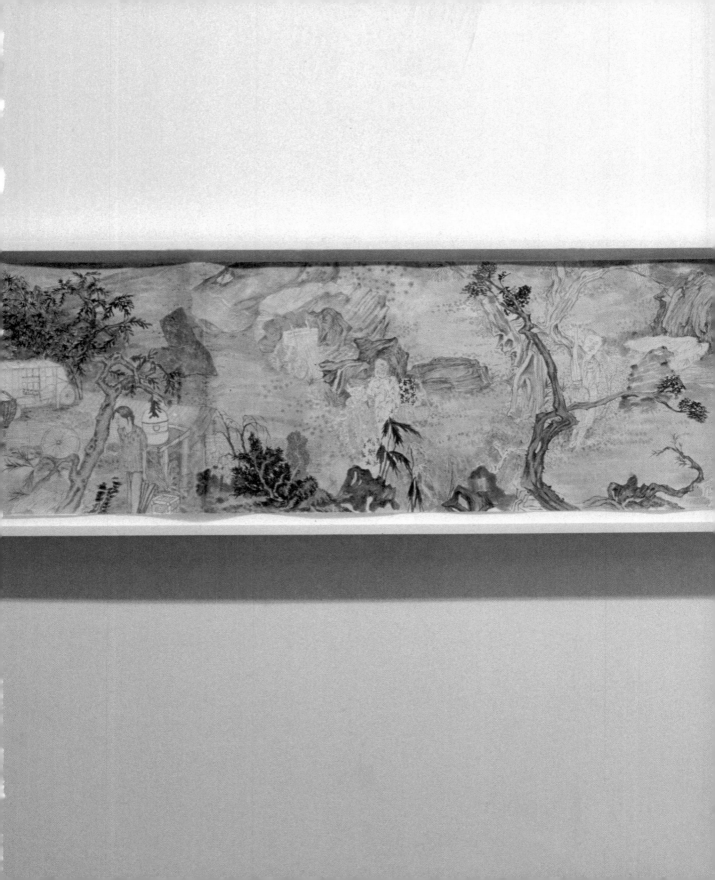

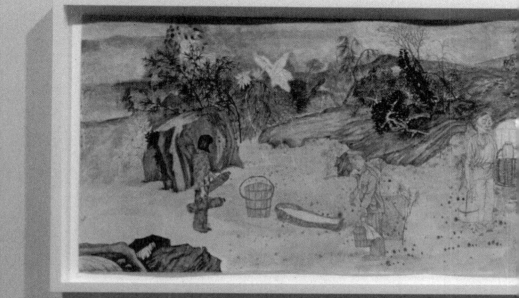

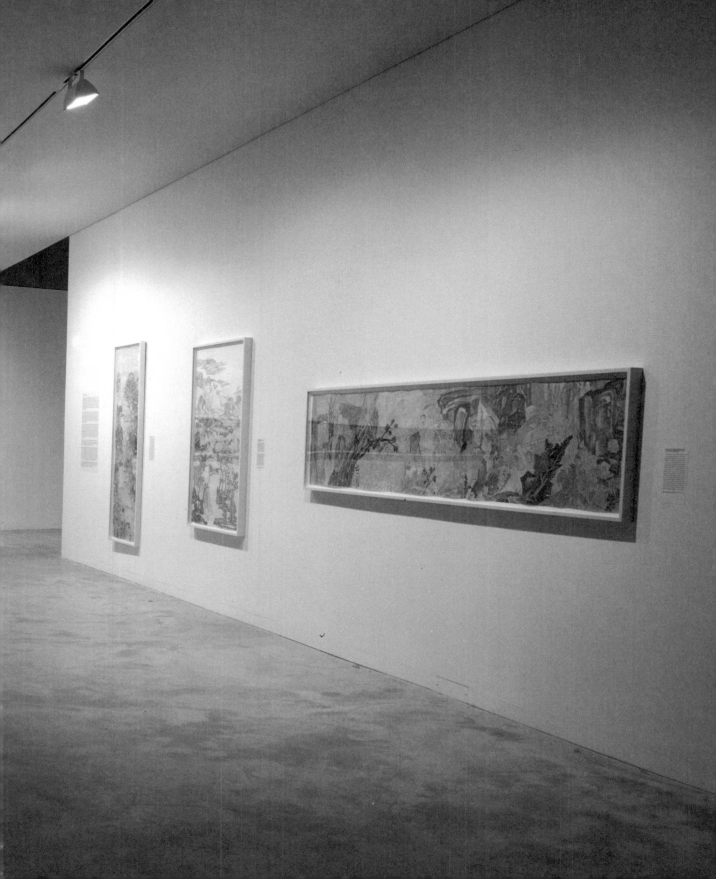

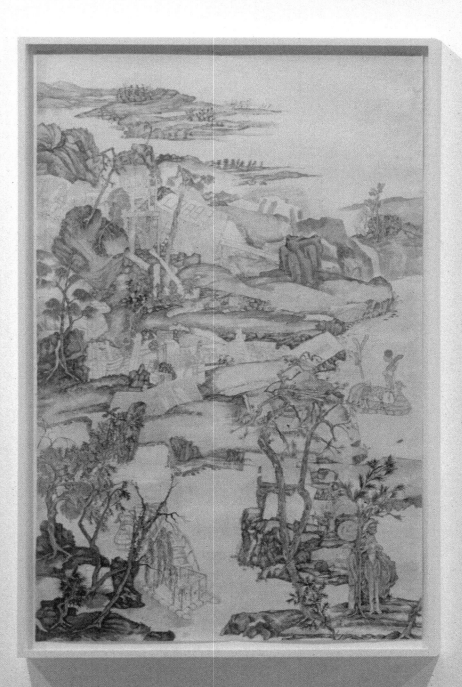

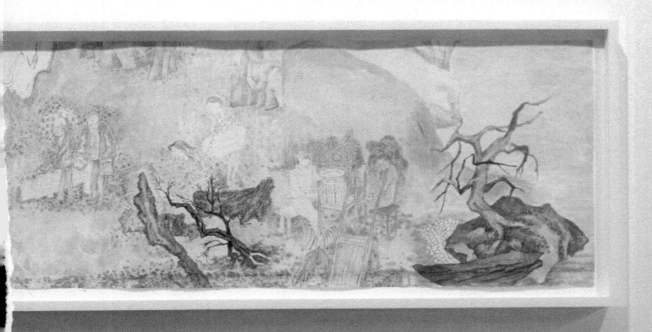

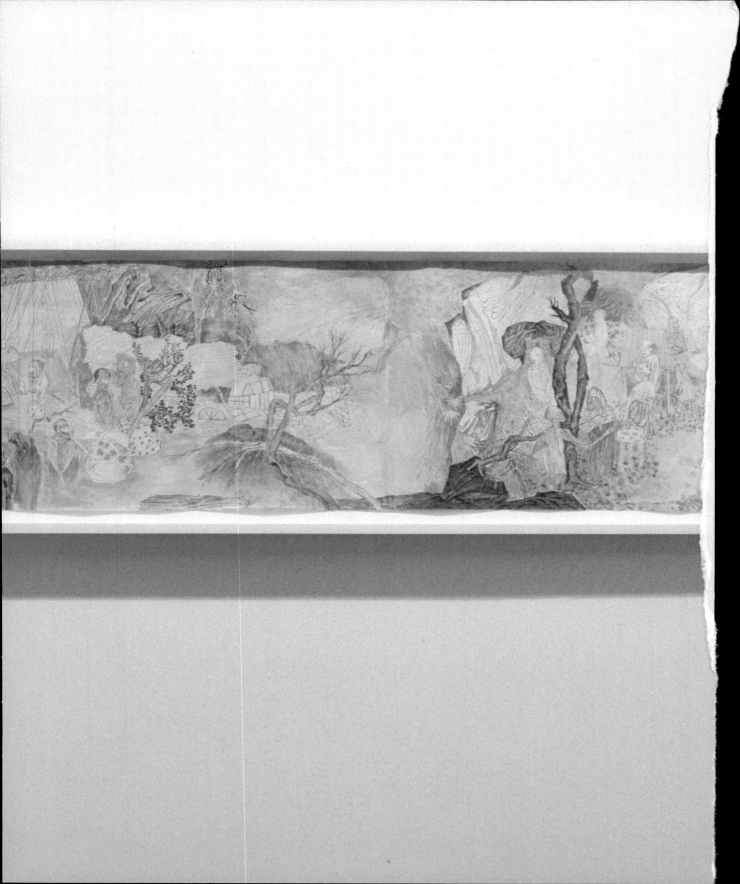

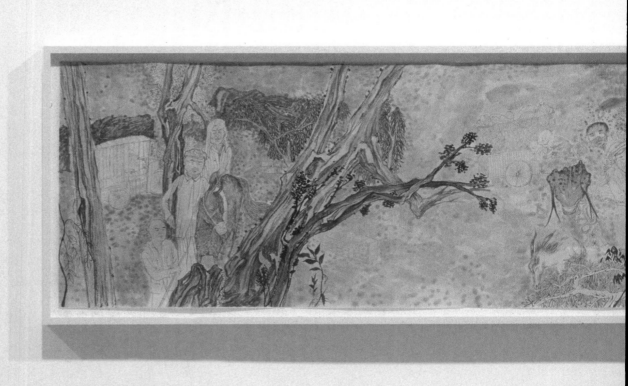

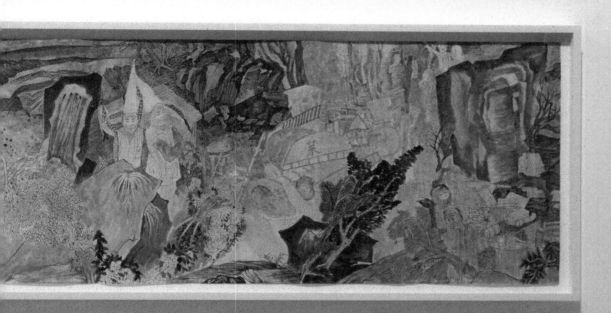

YUN-FEI JI AND THE UNCHANGING STRUCTURES OF HISTORY
TAN LIN

Yun-Fei Ji was an artist in post-revolutionary China when state-ordered mandates for socialist realist art held sway at the Beijing Central Academy of Fine Art. Ji attended the Academy in the late 1970s, where he encountered Soviet-influenced styles of workforce portraiture and the requisite oil paintings of Mao Zedong, Red Guards, and factory workers. He also witnessed the aesthetic of socialist realism forced upon his teachers. Given this background, it is not surprising that Ji, after he came to the United States in 1986 to study art at the University of Arkansas, gravitated to more parodic forms of political commentary. By the late 1980s, he had found his subject: the historical processes wherein the fractured and ideologically opposed "traditions" of Chinese painting come back to haunt the present. In other words, Ji came to America while his painting technique traveled back to China.

In their subject matter and technique, Ji's paintings at first resemble Southern Sung or Ming dynasty scrolls. Ji typically uses ink, applied with a variety of wet and dry brushes on mulberry paper. He will sometimes "wash" out the drawings and the paper, redrawing or adding coloring (in the form of traditional Chinese mineral pigments) onto paper that is sometimes wet, sometimes dry, and sometimes, as Ji says, "half dry." When the paintings dry out completely, the result is a mottled, crinkled paper ground that looks like it has suffered the enervations of a premature antiquity experiment. Colors vanish into nothing; a variety of ink lines, dots, brush strokes, and "accidental" splotches wane against the soaked ground of his paintings—only to re-emerge with demonic vigor elsewhere. Ji's handling of ink, reminiscent of the Chinese dynastic masters, is partly parodic since the subject of Ji's artisanal techniques is the failed revolutionary ideologies of China's recent past as they inundated—much like Ji's inks—the Chinese landscape, disrupted China's semi-rural geography, and eradicated a way of life. Looking

at Ji's paintings is like looking at those distant landscapes that for centuries have preoccupied the meditative masters of Chinese painting but that now seem to be leeched of their colors in a kind of visual and moral contamination and a dissipation of the vital *ch'i*. More importantly, the paintings illumine a paradoxical historical process: the premature aging of a revolutionary ideology into present-day relics, what the German philosopher Walter Benjamin, examining the arcades of nineteenth-century Paris, described as emblems of a prehistoric modernity. If history is a dream world, Ji's paintings are historical conduits; through them pass the weakly meditative colors of all those things—the Chinese landscape, revolutionary change, ghosts—that can no longer be seen. Ji's paintings are paradoxical: they depict "modern" China but the paintings themselves look like archeological relics, fashioned out of paper and constructed with the most artisanal of methods. The anachronisms of centuries-old traditions of Chinese painting and the enfeeblement of revolutionary social programs are two dialectical images of the same processes of history.

Among the historical currents addressed by Ji's paintings are the Great Leap Forward, with its call for steel furnaces in every backyard; Mao efforts to mobilize the youth of China and transform the nation from a lumbering agrarian giant into a major industrial power; and, most recently, the Three Gorges Dam project. Ji also focuses on the long and turbulent years of the Cultural Revolution, the era of collective farming, the years of Richard Nixon's ping-pong diplomacy, as well as such nineteenth-century precursors as the Boxer Rebellion and the Opium War. The residues of such revolutionary projects of modernization litter his paintings, which form a skeletal cross-section of an ongoing historical process. In Ji's paintings, nature, like history, takes on the faded appearance of something x-rayed and disassembled—much like the outlines of abandoned houses and automobiles. In Ji's paintings, nature has become an attenuated stylistic device, a species of false ideology: nature is scant and defoliated, people are walking skeletons or colorless ghosts in abandoned villages, social activity is confined to unenlightened sexual servicing, outdoor spaces appear cramped and interiorized, the horizon line drops out, portions of the paper

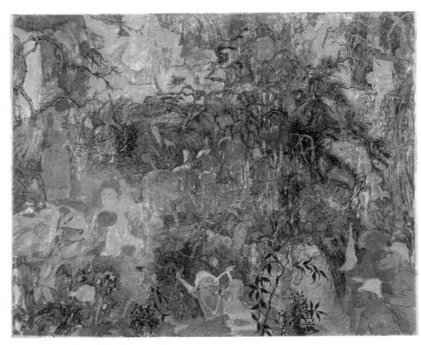

Dinner at the Forbidden City (2001)

are unpainted or uncolored, and citizens who are not yet dead scavenge off a moribund land. History, especially the history of modern China, looks like a truncated Confucian ode.

Despite their traditional appearance, the paintings dramatize the continual displacement and purging of people, politburo heads, industrial techniques, political beliefs, monastic ways of life and aesthetic styles. The paintings mimic the violent processes of history by replaying past images, hallucinogenically importing into the paintings' dream chambers a host of contradictory visual signs: motifs from folkloric populist traditions, patterns from wood block and silk prints, and the stacked perspectives found in traditional dynastic landscape painting—along with the flat spaces of socialist realist painting. Ji's question is how the diffuse patterns of history are to be decoded in an age of disenlightenment. In Ji's *A Monk's Meditation on a Woman's Vagina Being Interrupted* (2001), the meditative staging of the painting is interrupted—literally—by a flood of water (unleashed by the Three Gorges Dam project) that spreads apart a woman's legs, tumbles a monk out of contemplation, and awakens a series of demonic historic forces: demons with pigs' heads, exiled enemies of the people wearing dunce caps, and anonymous purged leaders who watch the events from the shore. In this cosmos, all means of attaining sexual, religious, or political enlightenment are overturned by the time-flattening effects of history.

Unlike the work of his predecessors, Ji's paintings do not so much describe panoramic natural landscapes as they describe the effects of twentieth-century history on the "timeless" local geography and social practices of a people. Ji's focus is less on singular historical events than on the eras that defined a host of related social practices among a demographic group. Looking at the innumerable details of a Ji painting is like looking at a thousand close-ups of the quotidian life of a nation—its architecture, debased court life, governmental bureaucracies, geography, urban renewal projects, prostitution, modes of religious contemplation, and aesthetic styles. In *Bon Voyage* (2002), Ji describes one of the principal social practices in China today: tourism. This vertical painting, reminiscent of dynastic paintings of mountain peaks, is modeled on a journey. Ji again retrofits a

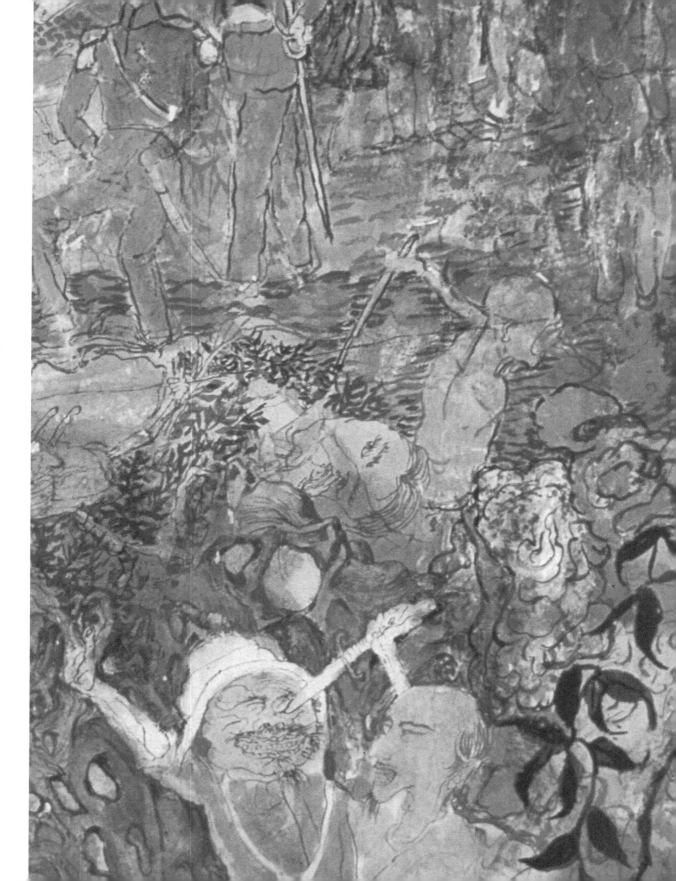

Chinese format to a modern subject and suggests that a spiritual pilgrimage is replaced with a package tour and that the latter is part of the recurring cycles of man's relations with the natural world. The painting begins in the lower left corner with tour guides on a luxury liner complete with swimming pool, balloons, drinking, and photograph taking. The boats are about to embark on a journey that begins in Sichuan Province and will pass upriver through the gorges before ending in the city of Wuhan. The tourists have come from the West. A woman who looks like Greta Garbo or a Hollywood star from the 1940s surveys the revelers, while a Western celebrity who resembles Larry King is interviewed in the foreground. But further upstream, people are fleeing the rising waters of the gorges as well as the pollution released by defunct factories. Two men in blue factory coats test for chemicals in the water. Automobiles are left abandoned. A cart containing a family's prize possession, a cow, is loaded and prepared for a journey of reverse tourism. People flee on foot with their possessions strapped to their backs. In this manner Ji creates a dialectical image: two versions of human migration, one coming and one going, yet both intertwined with changes in geography, the economics of tourism, and the final stages of a modernization plan designed to produce more electric power and increased leisure time for the populace. As a study in shifting energy cycles, long-standing transportation modes, and the exodus and dislocation of population groups, Ji's painting achieves a kind of hallucinatory non-transport and comes to rest, a cosmos robbed of its symbols, centered on a river that for centuries was considered the unchanging source of mystical energy and spiritual re-awakening.

In *The Picnic* (2001), Ji describes the effects of a massive economic shift that he correlates with a real historical event: the famine induced by the Great Leap Forward. In the late 1950s and early 1960s, the Chinese government's efforts to convert an agrarian economy into one based in industry was beset by gross errors of implementation as well as by a series of natural disasters, which together led to the death of nearly twenty million people from starvation. Ji's painting is compacted and claustrophobic. A withered pine tree sits in the center of the painting but is

hardly visible. The tree, a symbol of longevity, fathers a number of other tableaux: a woman sleeping on a car hood, enemies of the people (in dunce caps), and beneath the great tree, an overturned car. Groups of people from different historical periods arrive at this reverse-historical picnic, a mode of consciousness defeated by a single insidious and stupefied haze of debauchery, degradation, and blindness. The only thing related to nourishment is the ironic portrayal of a businessman getting a blow job.

In his most recent series of paintings, Ji describes the effects of the Three Gorges Dam project, along the Yangtze River, an idea broached by Sun Yatsen in 1919. After being overruled by Sun Yatsen's Vice Minister of Electric Power for environmental and engineering reasons, the plan lay dormant until Mao Zedong pledged support in 1958 to Lin Yishan, director of the Yangtze Valley Planning Office. In 1960 the plan was shelved again due to the famine resulting from the Great Leap Forward. In 1963 the idea was recouped as one of the Cultural Revolution's programs to revitalize China by creating an industrial "third front" in China's undeveloped southwest. International protests over the environmental and archeological impact and national protests on the dam's feasibility led China's State Council to vote down the project in March 1989. Ten years later, however, the government banned debate, sent the chief critic of the dam, Dai Quing, to jail, and denounced foreign critics as enemies of the regime. The dam was approved in April 1992, when former premier Li Peng pushed the proposal through the National People's Congress. Resettlement began the next year.

Ji's most recent series of paintings The Empty City, begun in late 1999 and 2000 and the subject of his current show at the Contemporary Art Museum St. Louis, elide the actual building of the dam. Although he describes the evacuation of hundreds of villages along the Yangtze, his main focus is the prior history of the dam, that is, the dated revolutionary ideology that fueled the project. Thus, Ji describes the flooding of the Three Gorges area in Sichuan Province as an event that has yet to fully transpire and whose ramifications are unseen or ignored. Again, the vanishing of ideas through time and history is Ji's principal subject, as is the human inabil-

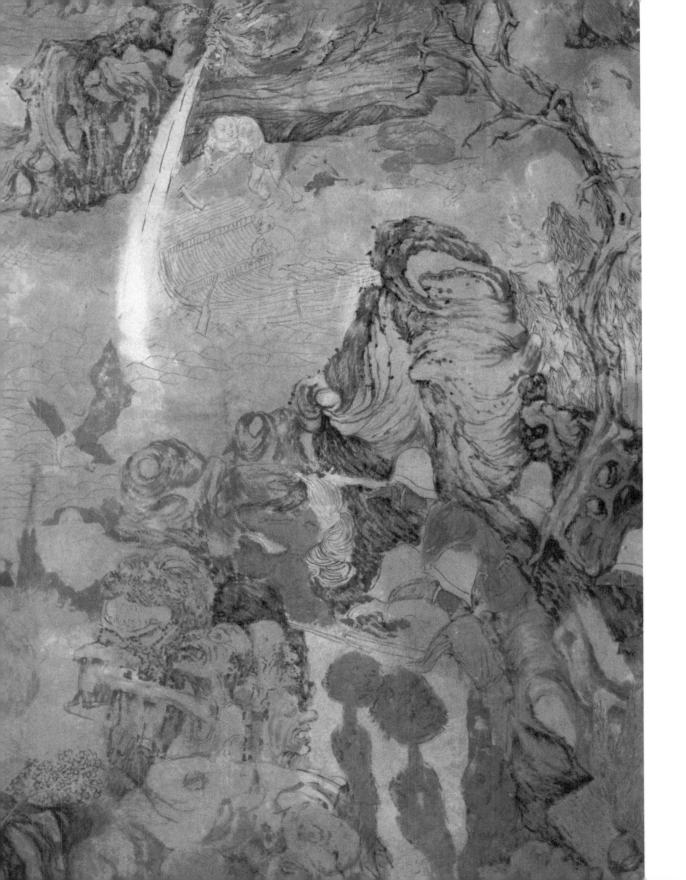

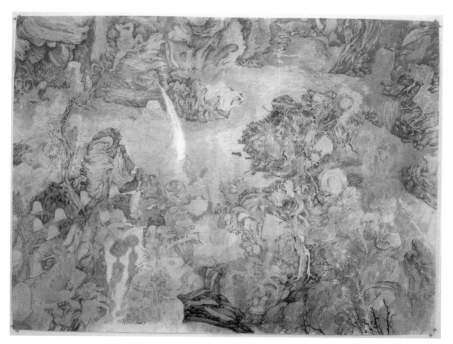

The Boxer, The Missionary, and Their Gods (2002)

ity to see the consequences of our actions. Global failures and blindness becomes an almost palpable part of the structure of Ji's paintings. That such transport, dislocation, and change take place almost invisibly on the wind and the water—subjects of much traditional Chinese landscape painting—is one of many ironies evident in the paintings.

The series progresses by misdirection, what Ji likens to "talking about a chicken to insult the dog." It is this quality that can make reading the series of paintings, widely differing in subject matter and tone, a voyage of feints and misreadings. In *The Empty City—Calling the Dead* (2003), Ji's subject is ostensibly a flood and evacuation, yet no flood waters are present. On the extreme left, a woman dressed in red—the only figure who is alive—turns her back to the viewer. She conducts what appears to be a proleptic series of talks with dead figures from the past: her reticent parents, a skeleton, her scavenger husband, and a man hanging his clothes out to dry. The figures are painted in colors so muted they appear to be outlines of humans; the flood has yet to arrive but they are already memories in a washed-out history. The painting depicts things left over, along with the dead who are seen and yet not seen Ji depicts an invisible history that has yet to take place and that cannot yet be spoken of.

Similarly, in *The Empty City—East Wind* (2003)skeletons, a karaoke bar named Sincere Love, and Red Guards hovering around a faded Mao poster circulate in a seriocomic tableaux. The miniature set piece reverberates with the shrill futility of theatrical productions scripted by party cadres during the Cultural Revolution. Unmoored in the midst of this farcical historical production are two ghosts from the past: Liu Shaoqui, Mao's designated successor, and a figure who resembles Deng Xiaoping. Both Shaoqui and Xiaoping were purged in the first phase of the Red Guard takeover. In *The Empty City—East Wind* (2003) Ji layers two historical events, the Cultural Revolution and the building of the Three Gorges Dam. The work is a montage of interlocking "stories," most of which appear to be spilling into the spectator's space, erasing the sense of contemplative distance. The organized and hierarchical

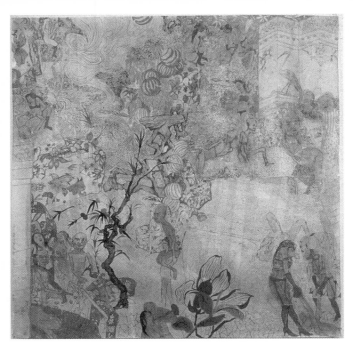

Rebellion of the Singing Girls (2002)

stacked perspectives prevalent in dynastic landscape painting are dismantled as is the linear movement common in much horizontal Chinese landscape painting. The painting plays out in a demonized, skeletal, comic-book space where melodramatic misdirections and detours suggest losing one's way. The Taoist unity of nature and man is dispelled, as is any possibility for spiritual unity with nature. In this painting, the individual's emotions achieve only a farcical correspondence with external reality (the notion of *wu*).

Ji's paintings compose an invisible calligraphic history or text, or, to be more precise, a phantasmagorical historiography of painting cycles embedded in China's physical geography. Not surprisingly, discordant painting styles—everything from Hieronymous Bosch to Sung dynasty scroll works can be found in a single painting—are fused or juxtaposed in the manner of a waking-dream tableaux. The works achieve illusive intensity because they no longer function as eternal values transmitted from generation to generation but appear as contingent ideologies, weak emanations of some greater truth that can no longer be glimpsed. As such, the grab bag of styles within a single work suggests the degree to which Eastern and Western aesthetic practices and traditional and modern philosophies have devolved into a morass. Ji's paintings do not depict historical eras so much as erase their reasons for existing. The progress of history becomes a grim joke. The paintings function in an exemplary fashion as manifestations of those incessant and violent activities of historical becoming, dissolution, and recycling that mark the unthinking appropriation of "historical" styles in the modern era. In Ji's paintings, the failed historical project of modernity at last reveals itself in a hallucinogenic flash. Yet, because the decaying factories, abandoned cities, and a lascivious gerontocracy have lost their revolutionary luster, perhaps it is possible to finally see these things as the illusory images of progress that they have always been, what Theodor Adorno termed "second nature" in describing the "alienated, reified, dead world" that the world had become.[1] As Adorno elsewhere noted: "the petrified life within nature is what history has developed into."

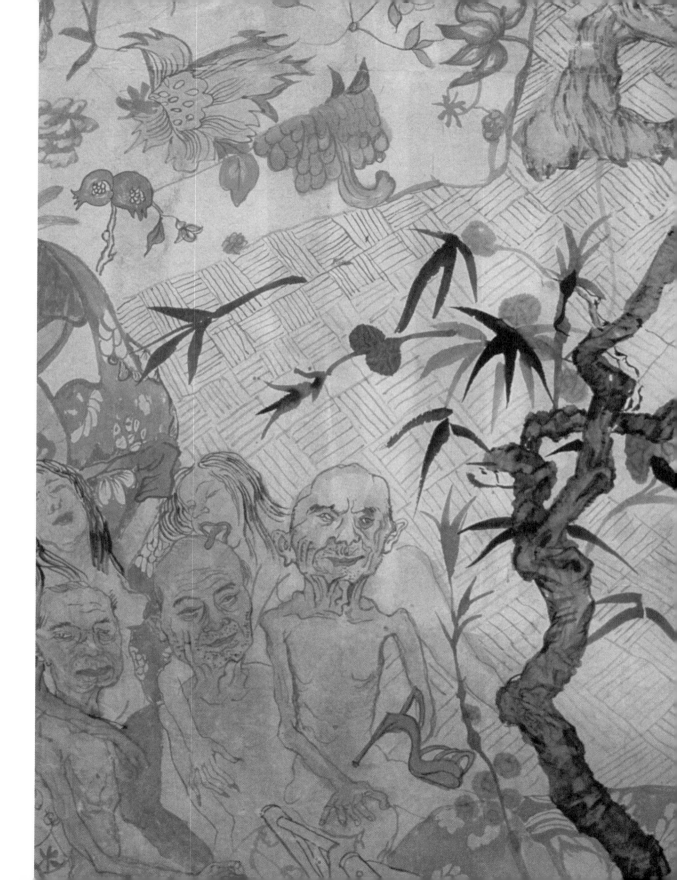

Ji's paintings reflect both Eastern and Western historiographical methods, and they revamp the tradition of Western history painting; they are strange, quasi-mystical geo-historical dream chambers that derive as much from the renderings of history by Francisco Goya, Max Ernst, and Max Beckmann as they do from Chinese landscape painting. History in the sense of discrete historical events is subsumed by an emphasis on what the French annalist historian Fernand Braudel termed "the longue duree," a geographical time marked by the unchanging patterns of daily life and concerned principally with those methods of food production, shelter making, and migration that have marked Chinese life for centuries. Ji demarcates the slowly recurring cycles of nature's destruction by man, the exilic movement of large population groups across the land (whether brought on by either natural or human action), the persecution and destruction of various population groups, and the stubborn weight of the humanly made quotidian things of the world—everything from tractors, electric generators, pleasure boats, and makeshift tents—as they are slowly and inexorably displaced by currents of Eastern and Western history. Ji's paintings are heavy with the weight of habit and the inordinate slowness of change.

Like Braudel, Ji describes the place where history and geography come together. His paintings elucidate Braudel's "geohistory," that nearly "immobile history of man's relations with the milieu surrounding him."[2] What one sees in Ji's paintings is the process of history wherein things are changed, almost imperceptibly at times, in a universe that is never static. Patterns of corruption and spiritual renewal recur *ad finitum*. East becomes West. Reform becomes degradation. Revolutionary change becomes the new social and moral order. The effects of history are panoramic, paradoxical, and contradictory. The works do not describe landscapes so much as cram them into the space of a historical narrative unable to accommodate them. This is a crucial reversal in Ji's work, which radically absorbs the Taoist notion that nothing is static and that the continual reversion of all things to their respective starting points is the way of the universe. As Lao Tzu noted, "Reversion is the movement of the Tao." Such a reverse logic drives the paintings, as it does Taoist thought and

most critiques of history as forward progress. Within a social system, or within a single painting for that matter, reform is regarded as a species of return and the progressive advance of civilization is deemed a dilapidation of the natural order. In Ji's paintings, history takes a huge leap backward. The present is degraded. Undifferentiated unity devolves into multiplicity without end in the movement of the Tao. The traditional Chinese landscape recurs endlessly as ruin or caricature, a dialectical image that reveals the idea of modern historical progress to be illusory and hollow.

[1] Theodor W. Adorno, "Die Idee der Naturgeschichte," in *Gesammelte Schriften*, vol. 1, *Philosophische Fruschriften*, ed. Rolf Tiedemann. (Frankfurt am Main: Suhrkamp Verlag, 1973), pp. 356–57.
[2] Fernand Braudel, *La Mediteranée et le monde médierraneen a l'epoque de Phillipe II*, 2nd ed. (Paris, 1966), vol. 1, pp. 15–17.

TAN LIN is a writer and artist who lives and works in New York City. The author of *Lotion Bullwhip Giraffe* and *IDM*, his work has appeared in *Conjunctions*, *Purple*, *Blackbook*, *Lingo*, *The Village Voice*, *First Intensity*, *New American Writing*, *Talisman*, *Asian American Writing*, *Cabinet Magazine*, *Pierogi Press*, and the anthologies *Premonitions: The Kaya Anthology of North American Asian Poetry*, and *The Gertrude Stein Awards 1993–1994*. His work has also been shown at the Whitney Museum of American Art, New York (*11-minute painting*, 2003); the Yale University Art Museum, Hartford, CT (2002); the Sophienholm Copenhagen, Denmark; and Marianne Boesky Gallery, New York (2001). Forthcoming are two books: *BlipSoak01 (Atelosin)* and *Opalescent Flouresence*.

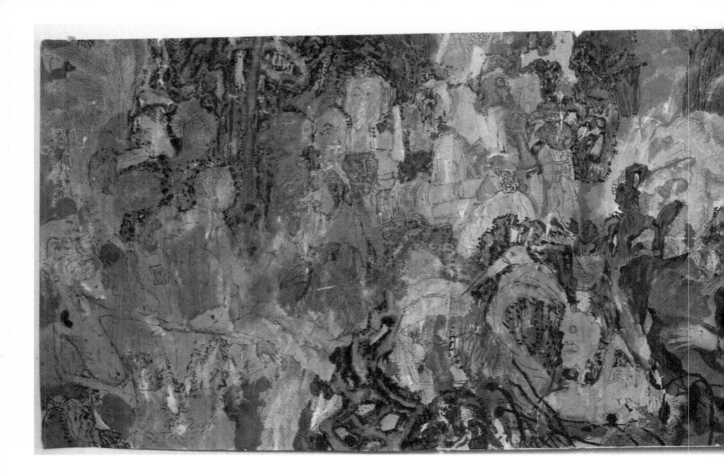

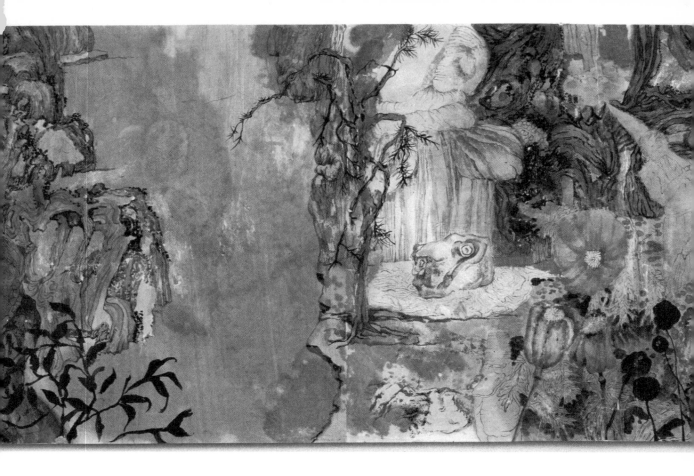

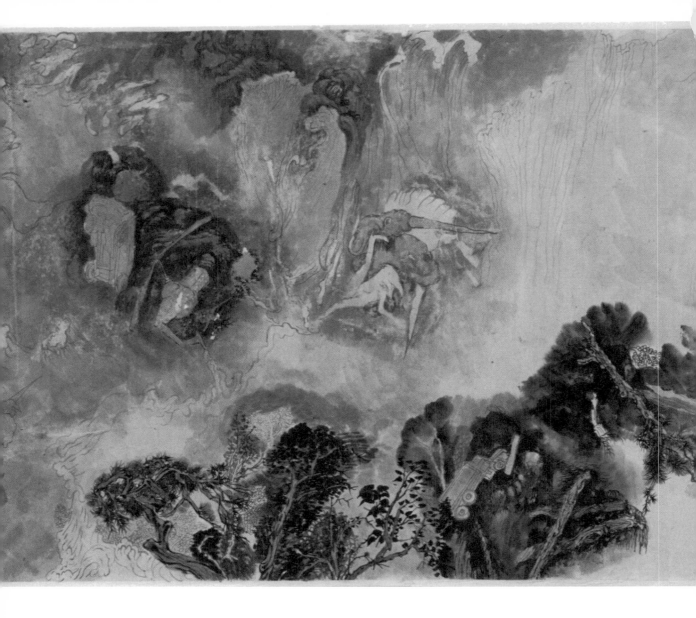

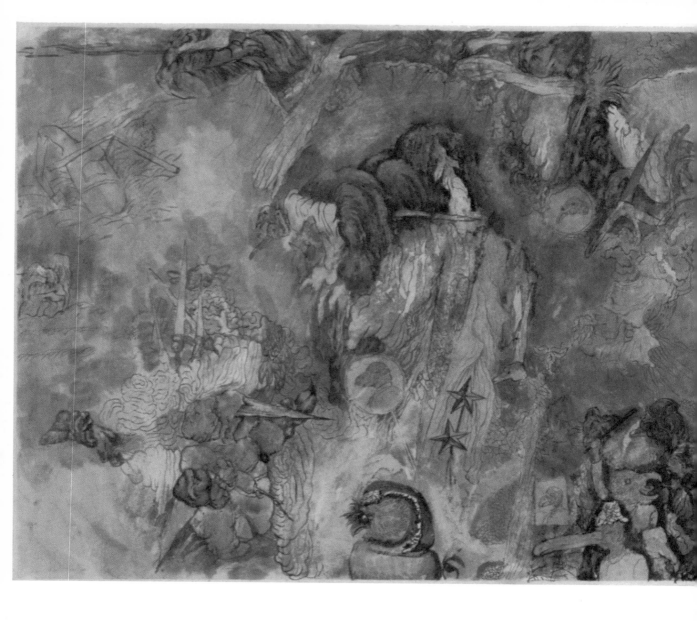

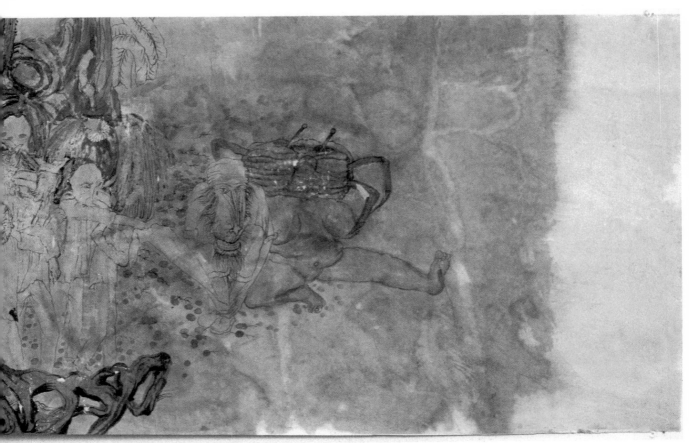

Nixon in China (2001)

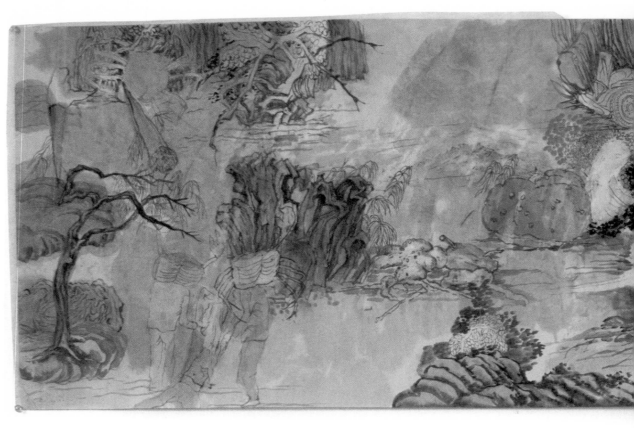

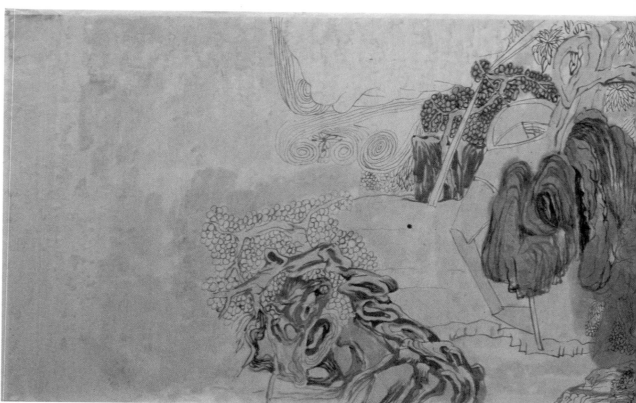

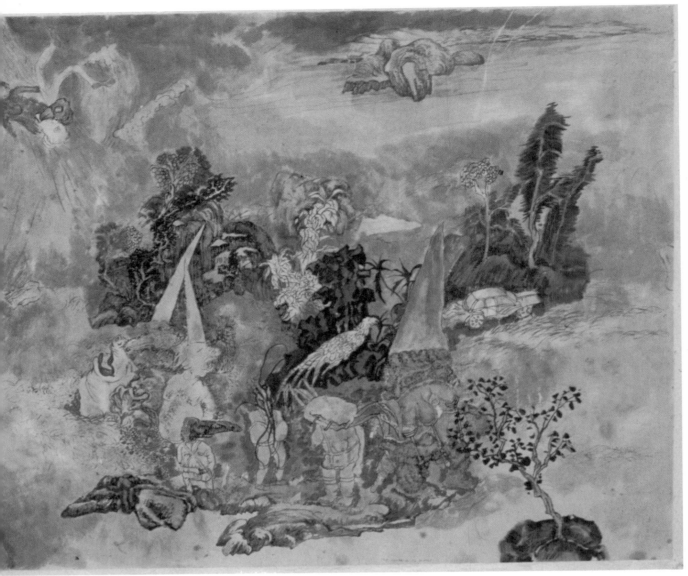

A Monk's Meditation on a Woman's Vagina being Interrupted (2001)
The Garden of Double Happiness (2001), following spread

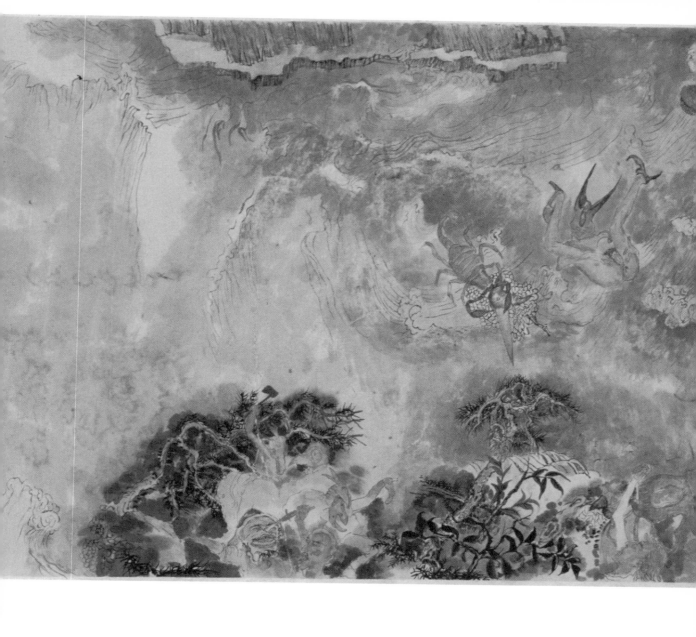

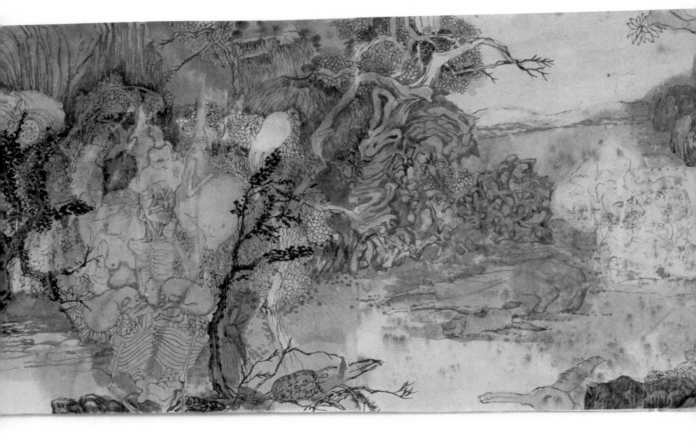
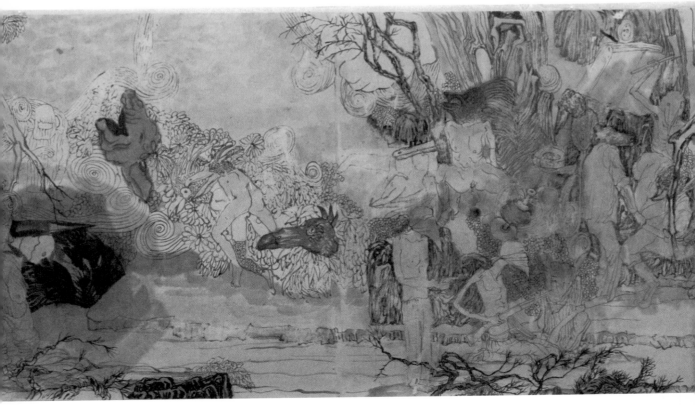

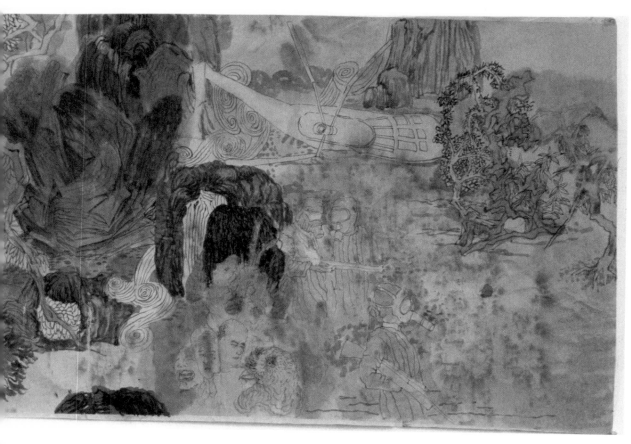

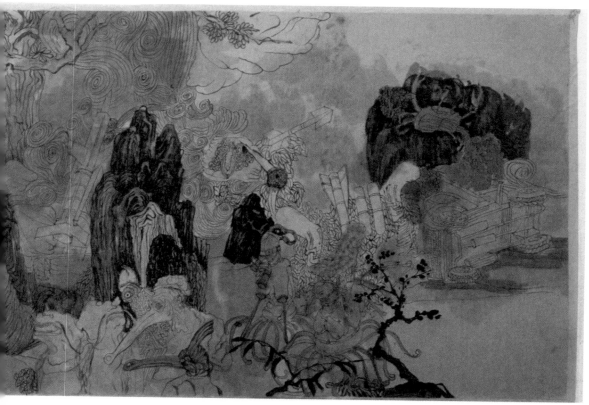

THE EMPTY CITY
GREGORY VOLK

In 1981, in Beijing, in what must seem like another life, Yun-Fei Ji heard rumors of an alarming plan by the Chinese government to build a massive dam on the Yangtze River in Hubei Province. That prospective dam (slated to be roughly five times the size of the Hoover Dam) would yield a vast amount of electricity but would also permanently flood some 350 miles of the river, in the process submerging entire cities and river towns, displacing well over a million people, and eradicating countless religious and historical artifacts.

This area, the Three Gorges district, has a particular resonance in Chinese history. It is a legendary site for natural beauty, recorded by generations of landscape painters. Known as a fertile territory for poetry, myths, legends, and phantasms, it is also home to a polyglot culture that has developed over centuries, including the presence of some forty minorities with their own languages and dialects. While comparatively remote from the power centers of Beijing and Shanghai, the Three Gorges area is hardly a wayward outpost on the fringes of the map. On the contrary, it is a national treasure, on the order of the Grand Canyon, albeit one in which natural grandeur and cultural complexities are completely intertwined. Indeed, this storied area was once the powerful Kingdom of Chu in the Warring States period (476–221 B.C.), where Taoism developed and where the great poet Qu Yuan, an originator of Chinese poetry, composed his own verses linking heavenly fantasies, courageous political challenge, and an impassioned connection to nature. Exiled for his political views, Qu Yuan wrote poems satirizing and condemning the corrupt and wanton government that he deemed had lost its moral legitimacy. When Chu was invaded and conquered by the neighboring state of Qin, Qu Yuan drowned himself out of grief, and his poems of protest seemed entirely prophetic.

One can only imagine what it must have been like to a resident of those cities and ancient river towns hearing the kind of rumors that reached Ji. Your home, your family's home, your ancestors' graves, the stores where you

shopped, all of the locales marked by your experience and memory were slated to be permanently submerged, and that's indeed what's happening now, as the project proceeds toward a planned 2009 completion date, despite intense international opposition. It is also interesting that a governmental plan so massive, socially disruptive, and environmentally hazardous would reach Ji and his generation through rumors, for no sustained discussion (let alone opposition) was allowed at the time. Progress, of course, including economic development, is one thing, but pursuing such progress in a way that literally submerges a significant part of the landscape, culture, and history is quite another. Progress of that sort could only come from an authoritarian government that is not accountable to those that it governs. Significant Chinese painters and poets throughout history have used all sorts of canny means to criticize governments that were similarly authoritarian and to articulate longing and aspirations in times of oppression, including socially coded landscapes, fantasy, allegory, and the subtle manipulation of readily identifiable symbols. That's the tradition Ji inherits with his paintings, which are at once visually enthralling, fraught with startling imaginative flights, and unflinchingly moral.

In 1981, Ji was an art student at the Central Academy of Fine Arts in Beijing, where he studied oil painting. He recalls, at one point, hearing another painter's exhortation to visit the dam in its initial phase — not to condemn but to celebrate and extol. This was a period not long after the convulsive Cultural Revolution when art making was still very much in the grip of Marxist ideologues demanding fealty to socialist realism, which meant that paintings and sculptures that glorified the achievements of the Communist era, at the expense of pretty much everything else. One of the hallmarks of the Cultural Revolution was a brutal dismissal of artworks, ideas, and relics signifying China's pre-Communist past, including the kind of landscape painting that Ji would later so successfully rejuvenate.

Ji was not personally immune to the upheavals and brutalities of the Cultural Revolution. His father, a military doctor, was largely spared, but his mother was sent for several years to a labor camp for hard work and political "reeducation" (comparatively speaking, a lucky fate). Ji was raised by his grandmother in the southern city of Hangzhou,

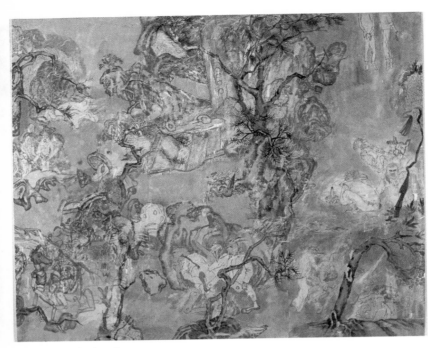

Hanging Garden (2001)

even after Ji's parents were eventually reunited in Beijing. Such a fracturing of a family, however painful, was hardly unique. It happened to millions of families across China, with lasting psychological repercussions for everyone concerned. In grade school in Hangzhou, Ji recalls his consternation and self-doubt when he was not allowed to join the Young Pioneers (the youth movement of the Communist Party), presumably because of his parents' situation, at a time when joining was the thing to do for a young kid just trying to fit in, have friends, and make do. The lunatic adult policies of the Cultural Revolution, in other words, were unfairly internalized by a child as personal embarrassment and unworthiness, and this also was hardly unique. By 1981 the dam was in Ji's consciousness, but dimly. In 1986 he received a scholarship to study art at the University of Arkansas. In 1989 the Tiananmen Square demonstrations occurred, and their subsequent suppression prevented Ji from returning to China until 1993.

I first met Ji several years later, when he was already deeply engaged with a promising body of scruffy, yet oddly elegant and meditative, works that combined aspects of traditional Chinese landscape painting, post-industrial wastelands, and Western cultural references. These works included drawings, paintings on canvas, and paintings made from ink and mineral pigments on handmade mulberry or rice paper. Ji has made this technique completely his own, though it self-consciously intersects with a tradition in Chinese landscape painting stretching back hundreds of years, including Southern Sung dynasty (1127–1279) painters such as Li Tang and Xia Gui, among many others, who were based in Yun-Fei Ji's own city of Hangzhou.

Ji was living and working (mostly working, it seemed) in a Williamsburg, Brooklyn studio loaded with paintings and drawings that were casually tacked to the walls, rolled up on various desks, or displayed as scrolls on tables. I was especially drawn to the works on paper, which were like nothing I had ever encountered by a young artist in Brooklyn, New York, or anywhere else, for that matter. With their subdued yet vital colors, crinkly paper, and intricate lines, these paintings seemed to be, simultaneously, from a few hundred years ago and from last week or this morning. Some were quite spare: for instance, twisting sections of landscape floating in empty expanses sug-

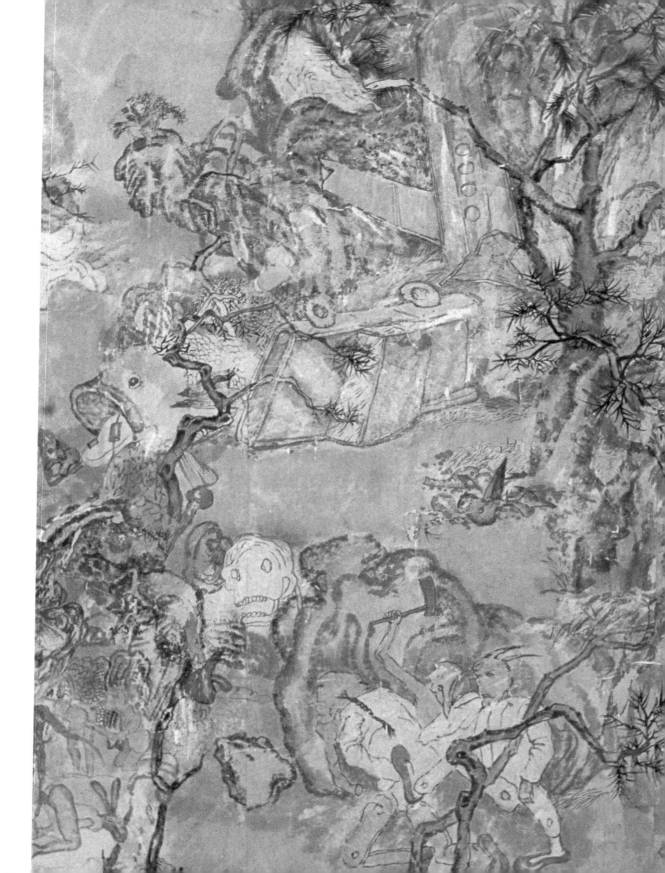

gested the drifting scraps of a broken-down utopia. Others were more dense and impacted. In both, one detected hints of mountains, mists, trees, flowing waters, and rocky outcroppings related to paintings by Sung dynasty forbearers such as Li Cheng, Fan Kuan, and Xia Gui, as well as to Yuan dynasty masters like Zhao Mengfu, Sheng Mao, and Huang Gongwang, among many others.

In Ji's case, however, these strange versions of a quiescent and meditative nature were seeded with alarming disturbances. I recall rockets and weapons; billboards for cigarettes; slightly greenish billowing clouds suggesting industrial accidents and nasty pollution; derelict vehicles abandoned in the landscape; other mutant vehicles and science-fiction machine parts that had no discernable purpose; circa-1950s gas pumps; ominous helicopters whirring through the air at an angle; tilted basketball hoops; bereft cartoon figures; and scattered bones; to mention just a few examples.

Ji's nature idylls seemed infiltrated by a junk heap apocalypse, and the junk came from both China and the West. Whatever calm one divined was inextricably linked to crisis, and the more time one spent with these works, the more one detected coursing lusts and violence, along with routine injustices and ecological havoc. The murky and impacted *Ink Growth #4* (1997) has a distinct horizon line at the top. You get the feeling, however, that you are not really looking at a landscape but instead into one—into the very ground, in fact, which contains a tangled array of legends, deaths, broken machines, entrails, and billowing smoke. *Among Mountains and Rivers* (1998) is likewise tangled and features shadowy figures, upended animals, and family possessions whirled about as if in a tornado.

These works and others from the mid- to late 1990s are very much paintings of exile. They are the paintings of an artist who is uncomfortably between two cultures, who is familiar with traumas, and who deeply understands the experience of displacement, on a personal and visceral level. Their pronounced psychological and social turbulence is also a form of both recollection and purgation. With these works, Ji was beginning to summon and confront the experience of growing up in China during the Cultural Revolution, with its frantic ideologies and rampant

oppression but also with its daily human rhythms and familiar objects, and to juxtapose those memories with what he was seeing and experiencing in his new, adopted country, which also had some obvious troubles.

Imagine living where Ji did, in that part of Brooklyn, while adhering in some measure to a Taoist ideal in which the properties and the beauty of landscape are entwined with visions of a moral social order. Outside Ji's studio to the immediate west was Kent Avenue and the East River waterfront, which was then, and still is, a turmoil of dilapidated piers, twisted railroad tracks, gutted warehouses, trash heaps, and suspicious puddles. Just to the north, in Greenpoint, there was a large sewage treatment facility and a huge underground oil spill, and a few blocks to the south a transfer station for low-level radioactive waste. Further to the west was Manhattan, and still further the post-industrial swampland of New Jersey, where nesting grounds abut oil tanks, and where aging elevated highways snake through foul-smelling marshlands, factories, and storage depots. The actual land in the land of the free, at least near Ji's studio, didn't look all that great. Instead, it looked difficult and contested by numerous technological, historical, and economic forces, each of which left its mark. And to the east, of course, there was China.

What I especially recall on my initial and subsequent studio visits is the inordinate pleasure of looking at Ji's paintings, and looking at them for a long while. Before all the ideas, memories, historical references, and cultural negotiation, Ji's paintings are visually stunning, and they revel in lines, colors, textures, brush strokes, contours, and fanatically detailed imagery. Oddly enough, for a frequent purveyor of mayhem, Ji is involved with redemptive beauty, and with painting as a "reverent experience," as Robert Ryman once memorably put it.[1] Ji reaches this beauty through an exacting process that involves multiple stages, and no matter how dense and claustrophobic his works ultimately are, every image and every single touch of the brush is there for a precise reason and nothing is wasted.

Typically, several layers of ink washes and pigments are applied to handmade paper, and sometimes scrubbed off and applied again, yielding subdued, yet still riveting, colors—a palette that suggests fading, erosion, immutable sadness, and loss, but also a stoic (and perhaps spiritually wise) acceptance. Ji's brushwork is virtuosic, including

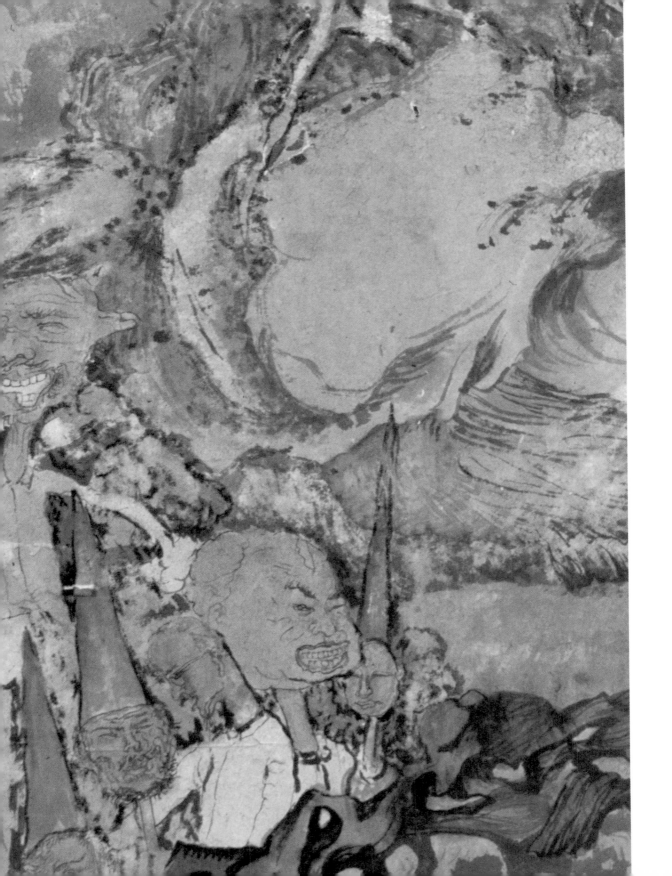

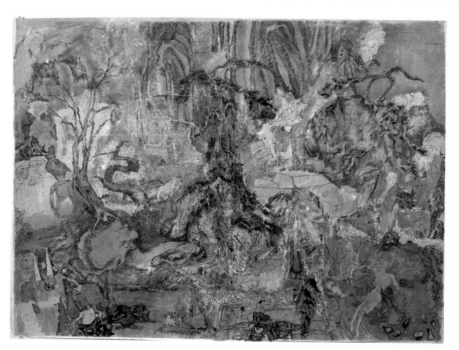

The Picnic (2001)

the tiniest of touches on craggy tree limbs and swaying grasses; thicker, more bulbous lines for other objects, both natural and manmade; and a mix of both wet and dry strokes, an ancient painterly technique in China. This varied brushwork communicates an extraordinary range of emotions or states of being, from whimsy and bliss to lethargy, agitation, and terror. Ji also has an uncanny ability to juxtapose light (to the point of ethereal) and dark demarcations, which gives his paintings palpable motion and depth. Multiple images loom into view, while myriad others seem to withdraw or disappear, turning the paintings into conduits between the seen and the barely seen, present and past, meticulous observation and unbridled imagination.

By the late 1990s, the Three Gorges Dam was more and more on Ji's mind, and over the next couple of years it would factor into several paintings. China itself also became an overt subject, in a series of paintings that address important episodes in Chinese history, including Maoist times. If Ji's landscape paintings rejuvenate a genre that was largely deemed outmoded and inconsequential in China, his works from the late 1990s and early 2000s do the same for history painting in the West, which is still about as out of favor as you can get. Figures abound in these works, including monks, gesticulating Communist leaders and functionaries, fitful People's Liberation Army soldiers with no place to go, ambulatory skeletons, hooded executioners hacking at victims with scythes, and various supernatural presences that are half-human and half-animal, some of which refer to folklore and myths, while others are purely invented by Ji. Commoners, such as workers and peasants, are very much present, but hardly as the heroic role models of socialist realism. Instead, they suffer and endure the machinations of the powerful with a quiet dignity, and they also exude a profound humanity.

The Forbidden City Ghosts (2002), in particular, revisits the Cultural Revolution as an orgy of drunkenness, perversity, hallucinatory violence, lethargy, and moral decrepitude—very similar to the poet Qu Yuan's condemnation of the Chu court. In Ji's painting, a pot-bellied Mao Zedong sits slumped on a chair, attended by young women in bright red (note the color) underwear. He is a cross between a meditating Buddhist and a near-comatose opium-

eater. His wife, Madame Mao, frantically masturbates with a dildo; next to her an assassin knifes a victim in the eye. Various other lesser leaders, apparatchiks, and freakish hybrids drift about in an evil haze. Executions are being prepared, and previous victims of executions reappear to haunt the scene. Wearing dunce caps, those denounced during the Cultural Revolution are present and watchful, while human figures with animal heads seem demonic and nightmarish.

As in many of Ji's paintings, small things loom large and large things (like Mao) seem very, very small, creating a vertigo-inducing painting. Multiple angles and rapidly shifting perspectives add to the pervasive uneasiness. Moreover, if the Communists posited themselves as the culmination of history, as brand new utopians squarely focused on the paradise certain to arrive, Ji is having none of it. Instead, he presents them as yet another prideful, dissolute dynasty that has lost whatever vision it once had and is now trapped in a vicious malaise. Interestingly, this painting consists of almost nothing but portraits and figures, dizzyingly packed together. Two mainstays of Communist aesthetics—hero-worshipping portraits and revolutionary murals—are invoked and then completely undermined. They are tools not for party power, but for a strikingly idiosyncratic vision that is part withering critique and part freewheeling magic.

With *Dinner in the Forbidden City* (2001) Ji revisits the 1840 Opium War, a volatile period when China and the West first really collided, presaging conflicts that would be so important later, notably with Russia and the United States. At the time, the British government was rapidly expanding trade in China, including opium grown in India, which was practically decimating Chinese society. When reformers attempted to outlaw the import and use of this drug, Great Britain used its vastly superior military power to force China to allow "free trade," although numerous other issues also entered into the conflict.

In Ji's painting, three British officers in their bright red uniforms sport outsized buzzards' beaks instead of human faces: they are both comical and horrific as they stand in the middle of a scraggly, benighted landscape surveying

scenes of seething violence. On the left, a human figure with a huge donkey head maniacally brays at the carnage, while another figure on the right scrutinizes things through a looking glass. One man's face contorts as he is stabbed. Nearby, another man swings a sword down with full force. Meanwhile, wearing their dunce caps, Cultural Revolution victims time-travel back to witness scenes of prior violence and oppression, and several Western gentlemen and gentlewomen in period finery thoughtfully gaze about—presumably they are the ones who economically benefited from the opium trade. The whole painting is a tangle of intercultural and national strife, and it's also a convincing protest against blundering colonialist intervention anytime and anywhere, including right now.

These allover works are filled with pent-up activity and reveal Ji's rising confidence in his ability to push his hybrid aesthetic to extremes. Much can be made of Yun-Fei Ji's profound connections with China and Chinese art history. However, equally important is the freedom he experienced in New York to begin making these dense, multi-layered paintings in which information seems to be coming from every which way. Ji's paintings of China are energized by the diverse visual culture of New York, as well as by the city's street life and jumbled architecture. While accessing different cultural and art historical sources, Ji's vivid maximalism is also related to approaches taken by his contemporaries, like Fred Tomaselli and Bruce Pearson, whose hybrid paintings have an eye-popping and mind-spinning power (in Tomaselli's case, leaves, pills, drugs, insects, and magazine cut-outs are mixed with painted forms and patterns; and in Pearson's case, ultra-colorful paintings of distorted language are created on molded Styrofoam). Both of these painters live in Williamsburg, as does Ji, and it is likely that the experimentation, generosity, succor, and go-for-broke ethos in the arts community there has buttressed Ji's personal engagement with a thousand-year-old-plus tradition of Chinese landscape painting, an engagement that might otherwise have seemed daunting, if not downright impossible.

In 2001, while in China, Ji traveled to the Three Gorges, visiting cities that were being dismantled in preparation for imminent flooding. There he witnessed weird juxtapositions: modern buildings in tatters next to hardscrabble

The three friends (1999)

houses where people were still eking out a living, functioning outdoor markets next to piles of debris, shorn-off rooftops on the ground next to people carrying pails of water and going about their daily lives. He witnessed real-life situations that were similar to the imaginative scenes he had already painted: which is an unusual example not of life flowing into art, but of art flowing into life. He paid close attention to those people who were still lingering in condemned cities, principally scavengers picking through the detritus for anything usable or saleable. These trips are the raw material for Ji's striking series of works *The Old One Hundred Names*, presented last year in New York, which focus on daily life in an imaginary village about to be flooded. His travels are also the raw material for a new series of paintings, titled *The Empty City*, which are presented here. In both series, the Three Gorges Dam is at the forefront of Ji's consciousness.

Interestingly, the dam itself never appears in any of *The Empty City* works. It is, most assuredly, there, but as a looming presence beyond the margins of the paintings. Precisely because it is not seen and must be imagined, the dam takes on an extra intensity and becomes a dark, foreboding force—a gigantic construction whose sole purpose is to control and restrict. Ji, one guesses, like many others of his generation, knows a great deal about being controlled and restricted. In Herman Melville's *Moby Dick*, while the white whale dominates Ahab's consciousness and increasingly dominates the *Pequod*'s doomed crew, it does not actually appear in the book until just a bit before the dire ending. Something very similar happens with the huge but unseen dam in Ji's paintings—a similar act of addition through subtraction. Ji also upends the dogmatic socialist realism of his of his youth, exacting a wonderful revenge. He does not paint the technological marvel touted by the government as a symbol of national prowess. Instead, he paints its catastrophic effects, with precision, ceaseless imagination, and a great deal of compassion.

Each of the paintings in the series features a city in eclipse, a city emptied of most normal life, a ghost city about as far from China's much-heralded economic miracle as you can get. One encounters ruins upon ruins in these cities, but as is so often the case with Ji's work, these ruins are eventful, visually and psychologically. One also

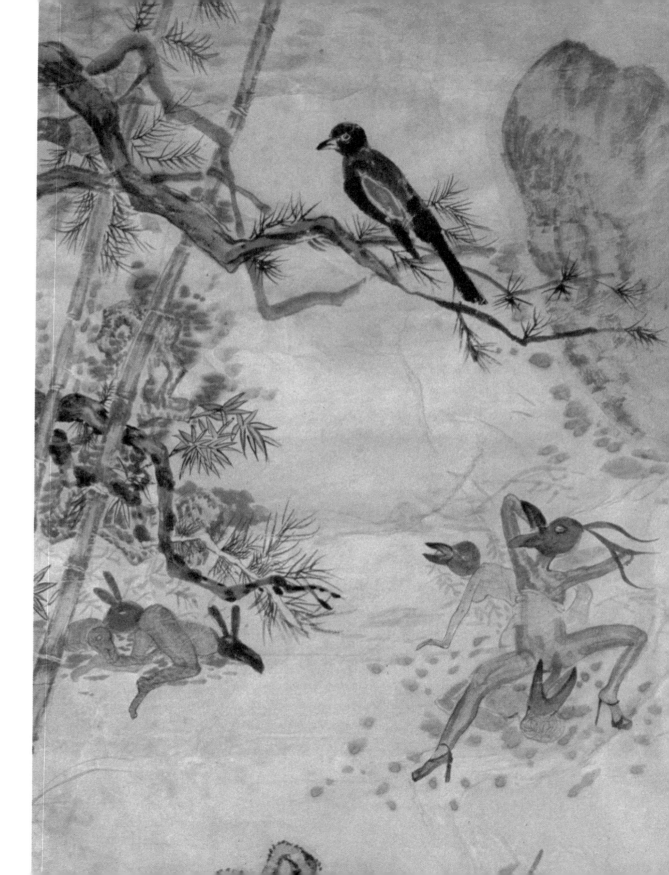

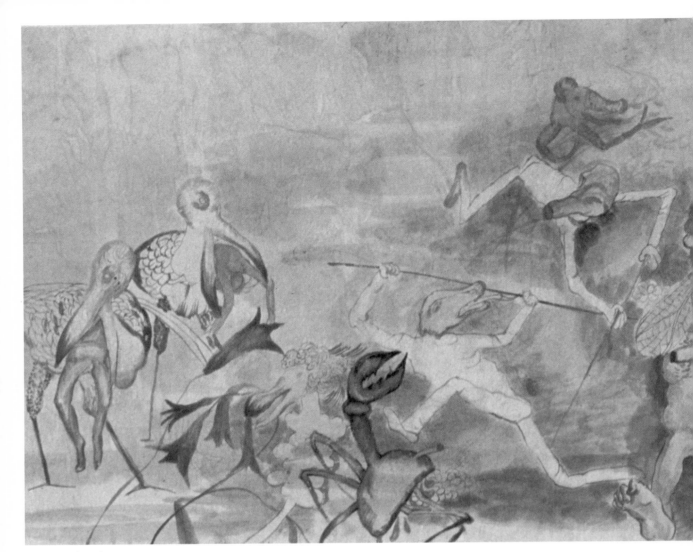

Mishaps II (2000)

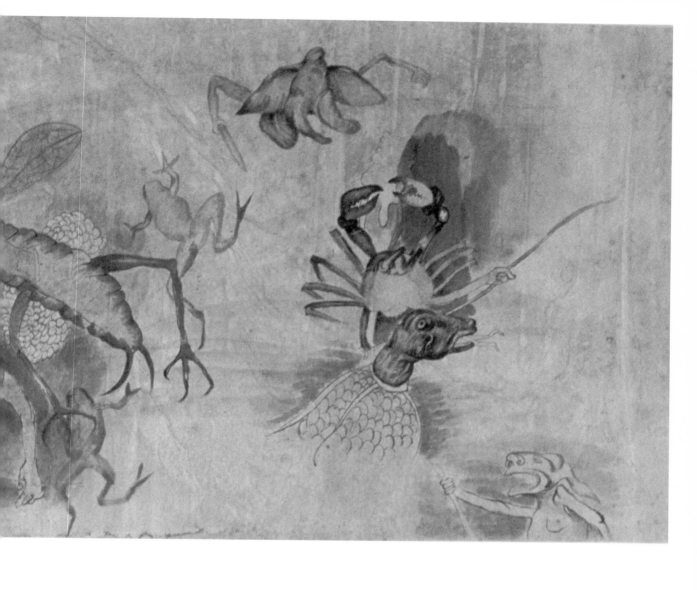

encounters figures, principally scavengers and the dead, trying to make do in a world of troubles. In the new China, with its bustling construction and moneymaking proclivities, no one is more marginal than urban scavengers and the dead. The first are China's untouchables, barely human presences existing on the fringes of society. The second are representatives of China's past, and they are rapidly being forgotten as a rush toward modernization levels old houses that were lived in for generations, threatens local traditions, and weakens family ties. (Ji, incidentally, is the only artist I know whose work posits an intense interaction between the living and the dead, who are not mere symbols but animate beings with a claim to the land and the culture who deserve their own comfort and well-being). In any event, Ji, whose family was riven for a season by the Cultural Revolution and whose period of study abroad turned into a lengthy exile because of political troubles in China, has a real affinity for the displaced, an insight into outcasts. He does not treat these outcasts as helpless victims, although their entire city is being taken from them. Instead, he presents subtle and evocative moments of dignity and strength—a dignity coupled with resignation, a dignity in the midst of catastrophe.

Each painting in the series provides a fresh perspective on this "empty city," including panoramic vistas and slice-of-life close-ups, things in the air and things on the ground. *Bon Voyage* (2002) prominently features a tour boat cruising down the river past the landscape and the cities in ruins on the river's banks. The Three Gorges area has been a hot spot for both Chinese and international tourism for a long time. Pro-dam government propaganda often touts how tourism will be even better in the future after the dam is built: for instance, a newly-created, elongated reservoir will be just fantastic for boating (although it will be interesting to consider exactly what's beneath one's pleasure craft).

In Ji's painting, this tour boat is filled with Westerners on vacation. They recline on the deck, frolic at the swimming pool, grin idiotically, and leer at each other as an apocalyptic shorescape slides by. They're having fun, but oblivious fun. The city on the shore, and all that is still occurring there, and all the suffering there, is so much pleasant

scenery. Sharp social satire gets mixed with an elegiac mournfulness for a physical and cultural destruction that is not exactly out of site, but certainly out of mind. Ji's title is also biting: "*Bon Voyage*" for a three-day trip down the Yangtze with all the food, drink, and relaxation you could possibly want; "*Bon Voyage*" for entire cities scheduled to disappear and for all their soon-to-be scattered inhabitants.

The Empty City – Fragrant Creek (2003) is a vertical work that shows how Ji expertly twists and distorts perspective. The top is essentially horizontal and conjures sweeping, almost limitless distances extending from a landscape nestled within and alongside placid water. A sizable blank space at the right introduces a Zen-like aura of emptiness and calm. From there, things precipitously tumble into escalating troubles, although the whole painting is done in muted and soothing earth tones and Ji's touch is everywhere delicate and light. As one's eyes move down the painting, the city comes into ever-sharper focus. The effect is of a camera slowly tracking from far-off to close-up.

Beneath the beatific upper scene, the placid river still curls through the city and the landscape, but trees with exposed roots tilt precariously and hills half-topple at odd angles. Houses and buildings crumble, shedding piles of ceramic tiles. The whole city seems to be fissuring before one's eyes, like an earthquake in slow motion. One notices details: a particular kind of Chinese truck, a particular cart with three wheels, a rickety wooden tower, a bicycle. Every now and then, you can just barely make out silhouetted figures collecting things from the rubble or perhaps cooking over an open stove. On the river, a couple of drifting, duck-shaped boats, one manned by two ghosts, seem ready to ferry excited school kids to an outing, but there are no school kids in this city and there is no excitation. You also have no clue whether these duck boats actually exist, somewhere, or whether they were concocted by Ji.

Ji often begins his paintings not with jets of enthusiasm — not with putting a passionate brush on a sheet of blank paper — but with diligent research, which can include reading books, consulting histories, viewing photographs and films, and on-site visits recorded with a digital camera. Such visits were essential for these paintings. Still, when Ji is

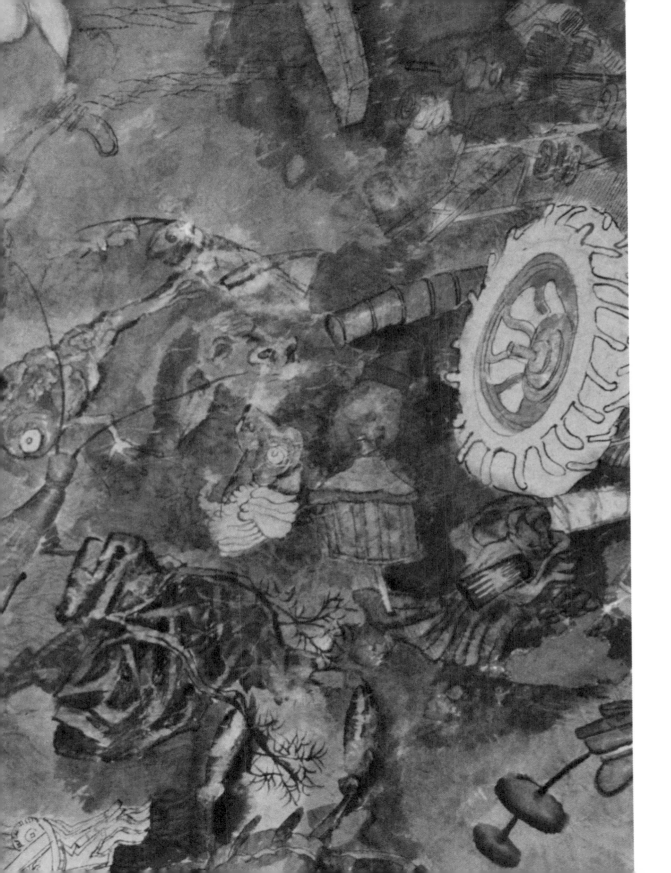

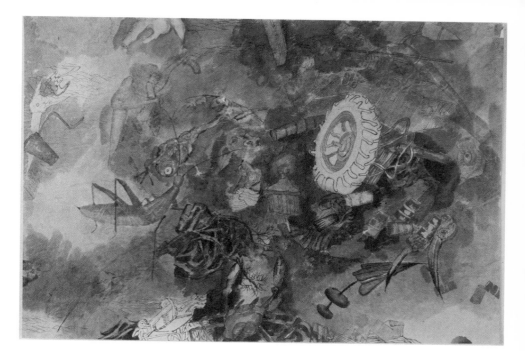

Passage (2000)

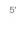

deeply into his paintings, all of this research factors in, but it also gets thoroughly transformed. Photographs, for example, are converted into notebook drawings, which, in turn, are sources for the numerous vignettes in his paintings. When the notebook drawings do enter the paintings, they are always altered, resulting in a blurring of fact and fiction, documentation and imagination—which is precisely what happens with the city in *The Empty City–Fragrant Creek*.

The river doesn't inundate anything; instead, it cuts through and wears away. At the bottom of the image, two comparatively large figures are emphasized, as they stand at the tip of a peninsula or an island. They are common people, probably scavengers. They seem at once bewildered and contemplative. With hands in their pockets, these two quiet men survey the destruction of their city, but as they do, they communicate a patient dignity, an ability to withstand and survive even the most egregious of offenses. And you sense Yun-Fei Ji's large empathy.

With both *The Empty City–Listen to the Wind* (2003) and *The Empty City–East Wind* (2003), the physical city recedes into the background and urban activity comes to the forefront. In these paintings a new element appears in addition to water, namely wind. In Chinese history wind is a metaphor for the Emperor and all his whims and decisions, as well as being a metaphor for revolutionary force. When one "listens to the wind," one attempts to divine where policy might be headed and what its effects might be. Two narratives begin to intertwine in these works: the Three Gorges and the Cultural Revolution. These are at once acutely personal and broadly cultural narratives as Ji explores his own conflicted relation to China. The connection between the narratives is also accurate. A project like the Three Gorges Dam is embedded in a system of utopian-minded government from on high, in which huge construction projects have often had dire human and ecological consequences. Mao also once wrote a poem anticipating the wonders of this dam, a poem that now provides inspiration from beyond the grave for a project that might very well turn out to be a boondoggle of epic proportions.

In *The Empty City–Listen to the Wind*, rendered in somber colors tending toward black and white, trees seem to be gauging the wind's direction, while little charcoal dabs conjure blowing leaves. The whole scene is anchored in

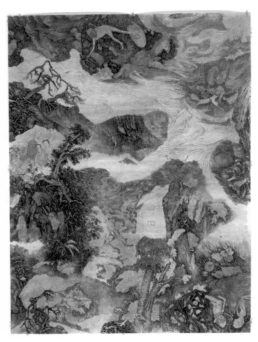

The Flood of Ba Don (2002)

the middle by a demon frog with a government official in tow. This oily, grinning frog seems like a child's most ferocious nightmare. Elsewhere, scavengers pause from their work to listen, and a one skeleton carries another—an example of the dead helping the dead. On the far right, amid twisted trees and crooked boulders, a huddle of Cultural Revolution victims observe another official issuing a decree. Throughout, faces are often wracked with sorrow, pain, worry, and confusion, an aspect of Ji's painting that has occasionally led to comparisons with expressionists like George Grosz and Otto Dix. But perhaps an even more pertinent comparison is with the great ninth-century Buddhist monk Guanxiu, whose paintings of the convulsed and distorted faces of monks are filled with raw emotion, and who introduced Buddhist notions of inevitable pain, as well as acceptance of that pain, into the art of his era.

With *The Empty City—East Wind*, everything whirls at gale force through the air: three People's Liberation Army soldiers bearing a megaphone; a picture of Mao with his face blotted out; and a placard; frightened villagers and dead soldiers; canopies; clothing; and trees. Basic directions are scrambled, including up and down, and perspective is completely askew. This is a vision of total havoc, a city blasted by an ideological wind and eroded by a politicized river.

The elegiac *The Empty City—Calling the Dead* (2003) quiets things down by focusing on one woman's encounter with her dead relatives. This lone woman wearing colorful clothes stands on the left, holding two bottles of water or tea. She is taking a break from her tough job as a scavenger. Stretching to the right is a succession of relatives, starting from her parents, who still look alive but whose clothes have lost their colors, and continuing to ever more distant ancestors whose flesh increasingly falls from their bones. Everyone is involved with daily activities, with cooking and washing, eating and conversing, and this long trail of simple, life-sustaining rituals contrasts with the life-rupturing effects of the dam. All of this—these comfortable home activities, this connection between generations, this basic connection of an individual to history in the broadest sense—will also be lost when the city is flooded.

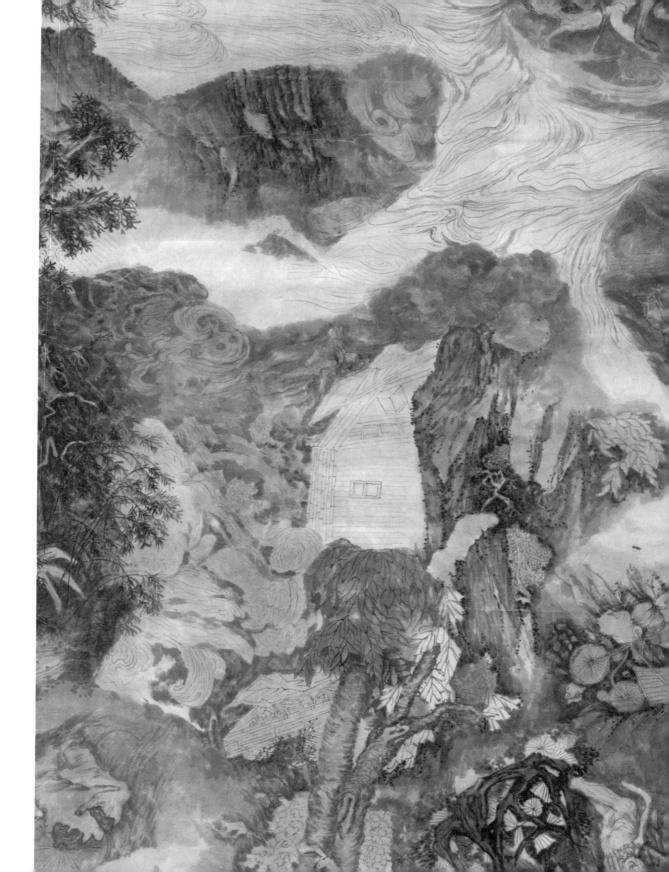

The Empty City – The Autumn Colors (2003) is a tour-de-force horizontal panorama of a city seen from a distance. Crisscrossing waterways seem to be claiming the city and land by degrees, but one still notices, and is enraptured by, exquisite trees with russet leaves and flowering plants poking through the rubble. Much of the remaining land is neatly piled with useful things, like stacks of tires and coiled hoses, salvaged pieces of architecture, and wooden vehicles for transport; the last scavengers here are still industrious and pragmatic. Two skeletons sit down to rest, while another sleeps in a boat. All are exhausted: coping with destruction is hard work. You know what's going to happen with this city; there's no mystery left. Still, Ji invests this desolate scene with a lyrical beauty, as well as with an aptitude for humanity in the most beleaguering of conditions.

Starting with a specific place subject to specific political, economic, and historical forces, Yun-Fei Ji has come up with a remarkable body of work that functions on multiple levels. His *Empty City* paintings radically update Chinese landscape painting and radically extend painting as it is practiced in this country: at once fiercely socially engaged, visually bedazzling, and poetically lively. These works probe his own complex and conflicted relations with his homeland, but also metaphorically explore how individuals and local cultures throughout the world are also facing inundation from various sources.

[1] Robert Ryman, untitled statements, in "The 60s in Abstract: 13 Statements and an Essay," *Art in America* 71, no. 9 (October 1983): 123–24.

GREGORY VOLK is a New York-based art critic and curator who contributes regularly to *Art in America* and other publications. Among his numerous contributions to artists' catalogues are essays on Mark Dion, Roxy Paine, Karin Sander, and Fred Tomaselli. Together with Sabine Russ, he has curated eleven exhibitions in New York, Germany, and Korea. A member of the Board of Directors of AICA, the United States section of the International Association of Art Critics, he is also a Visiting Professor at the Rhode Island School of Design and State University of New York–Albany.

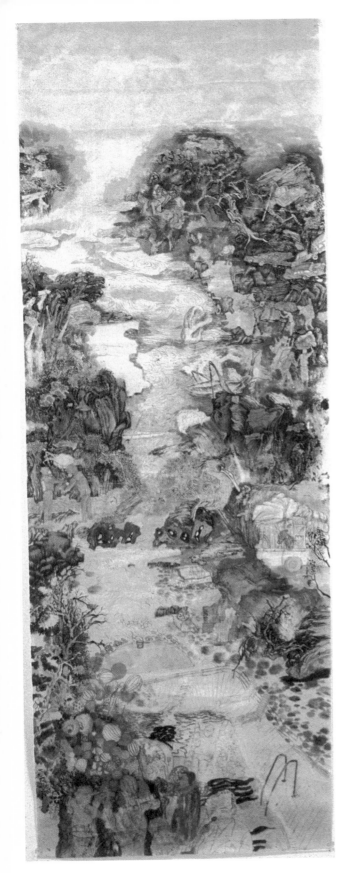

Bon Voyage (2002)

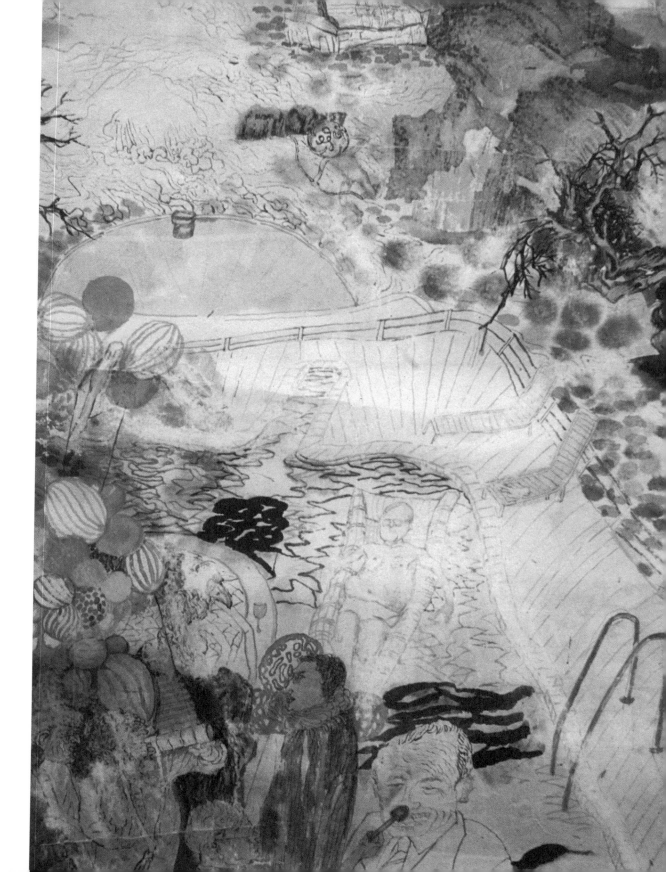

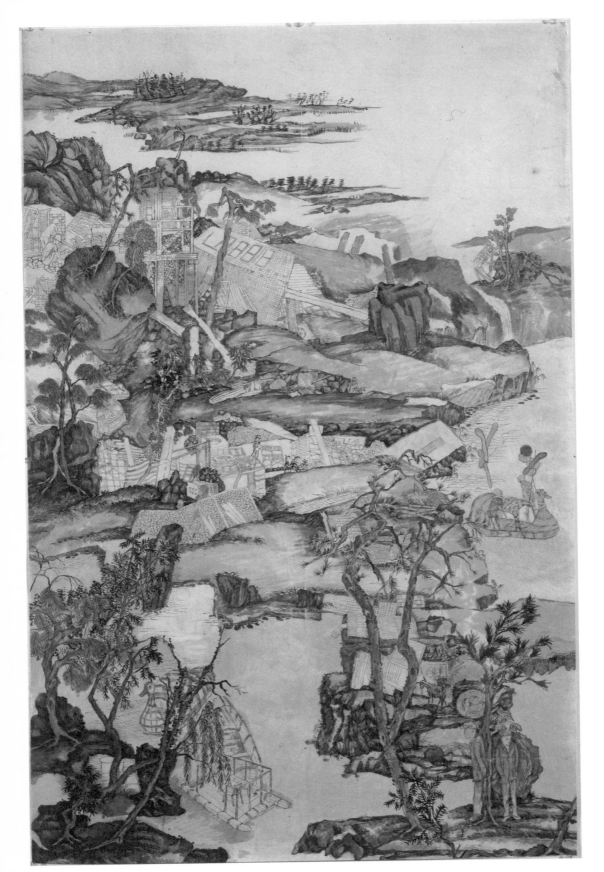

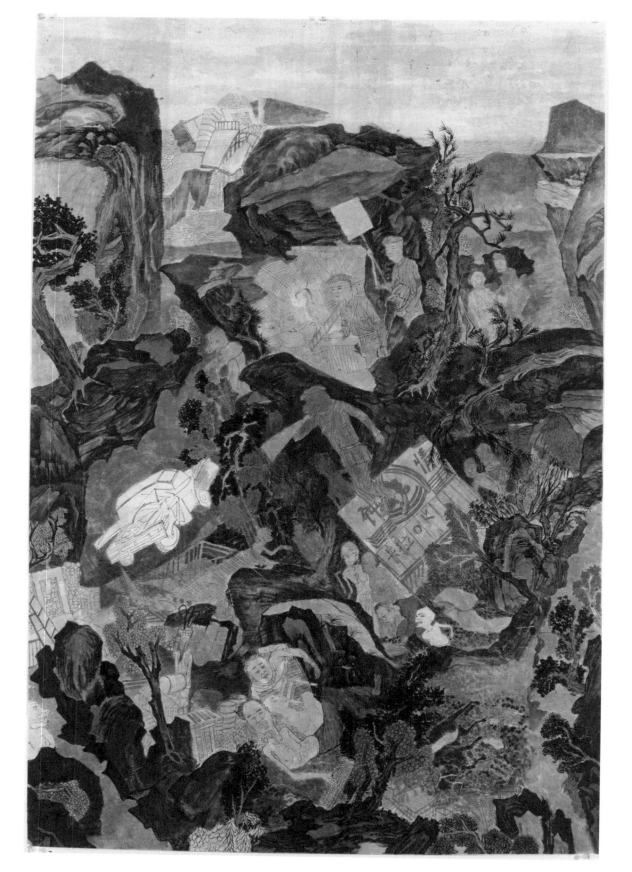

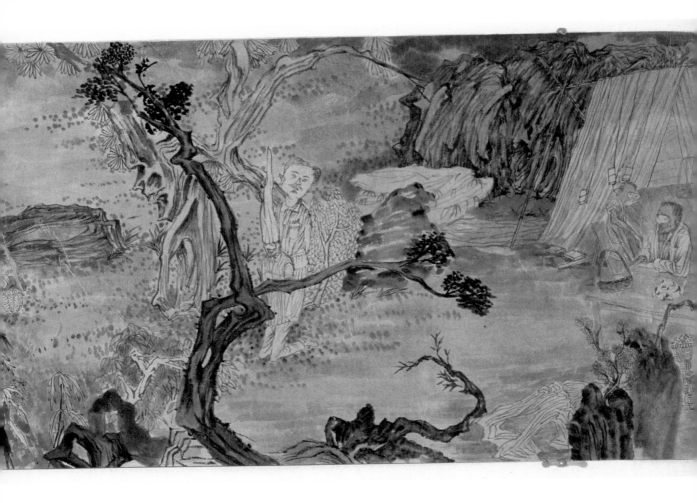

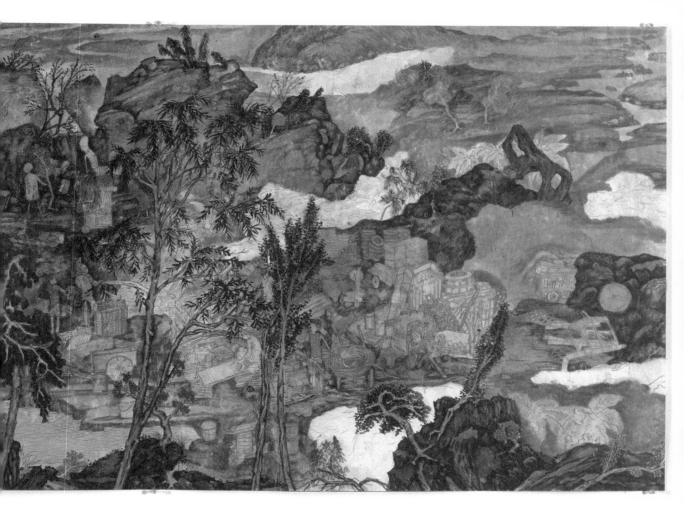

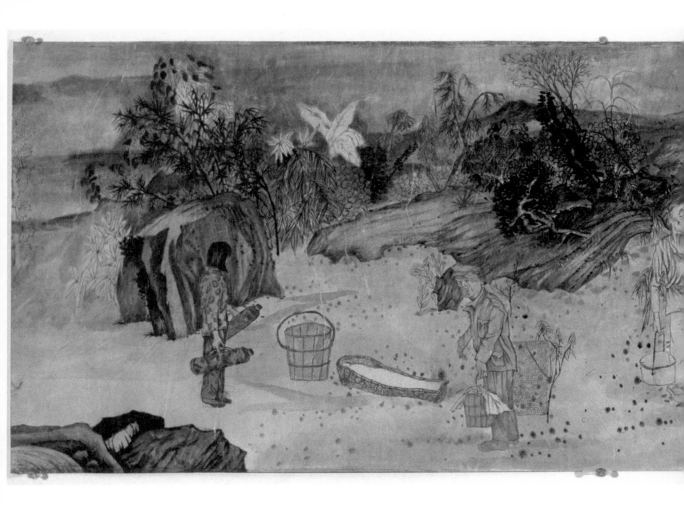

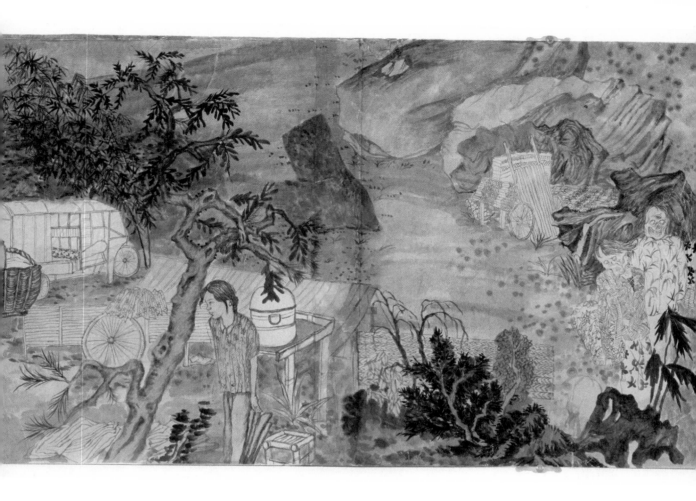

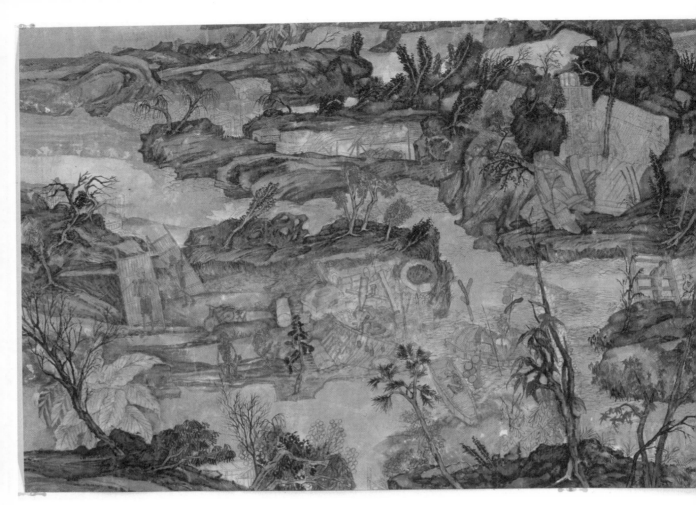

The Empty City – The Autumn Colors (2003), above
The Empty City – Fragrant Creek (2003), far left
The Empty City – East Wind (2003), left

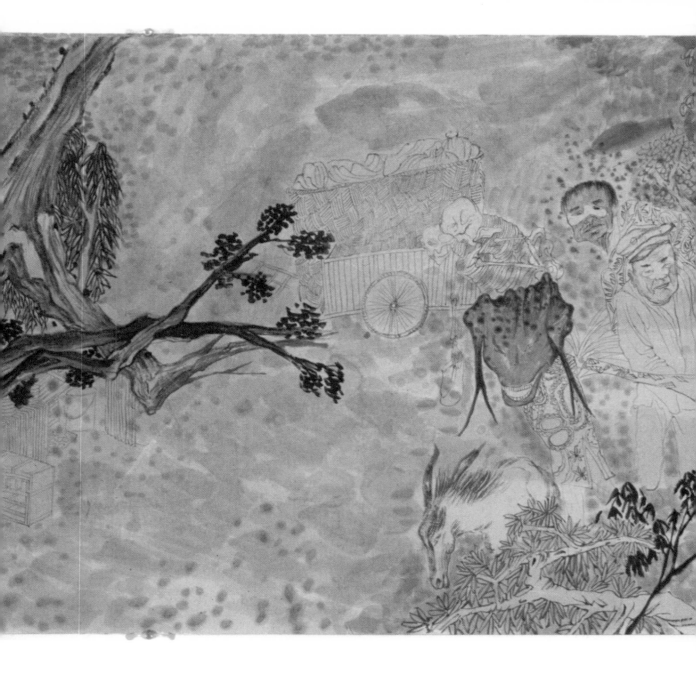

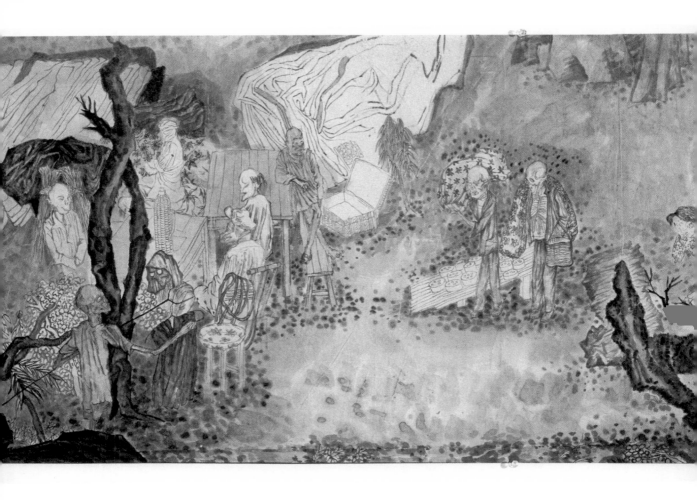

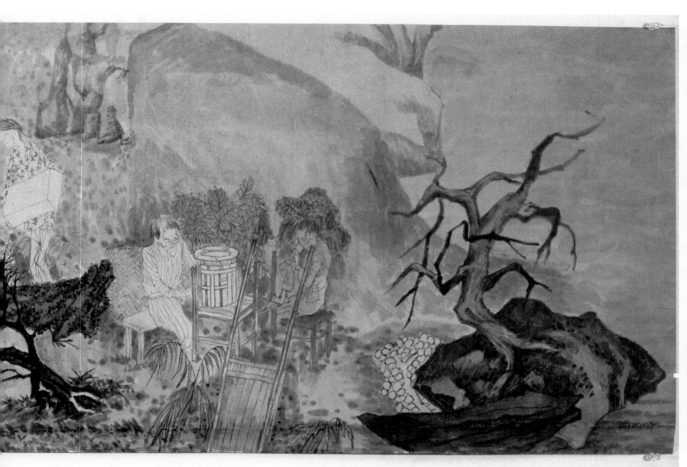

The Empty City – Calling the Dead (2003)

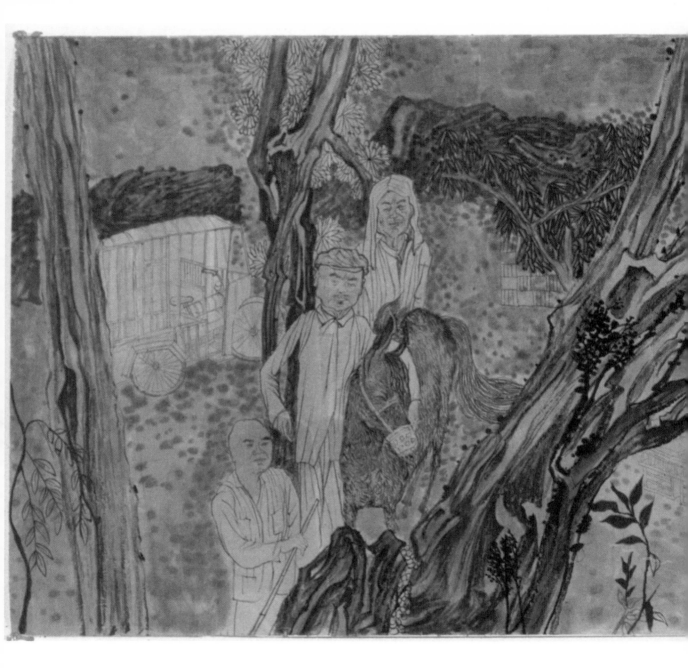

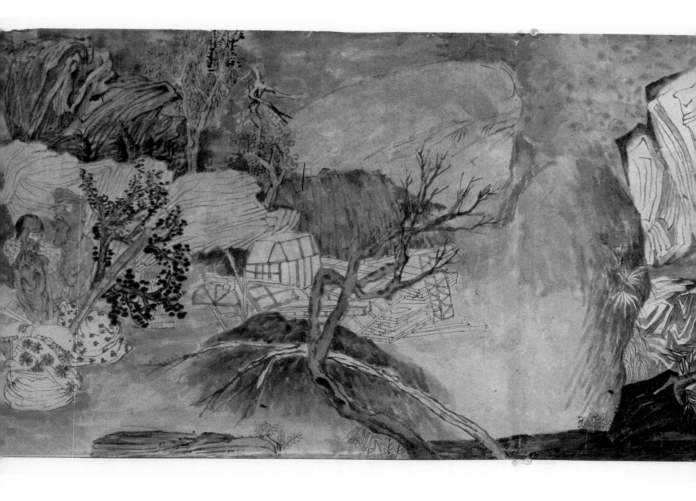

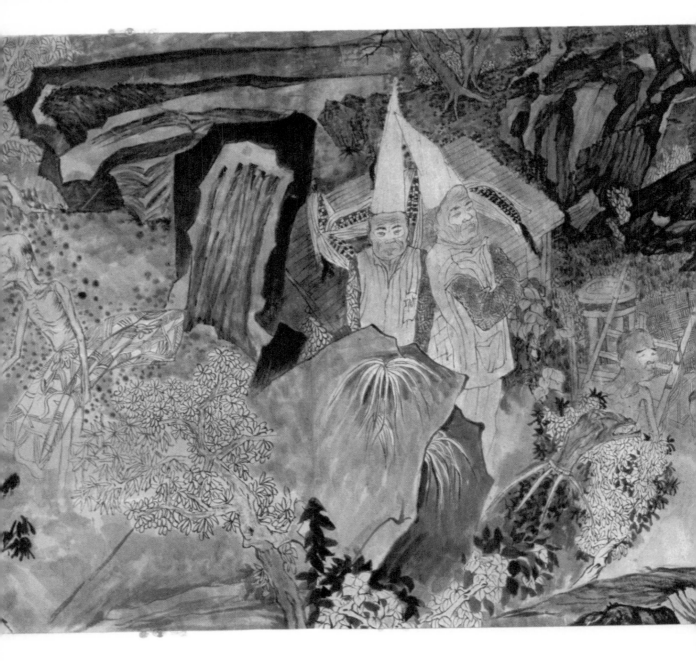

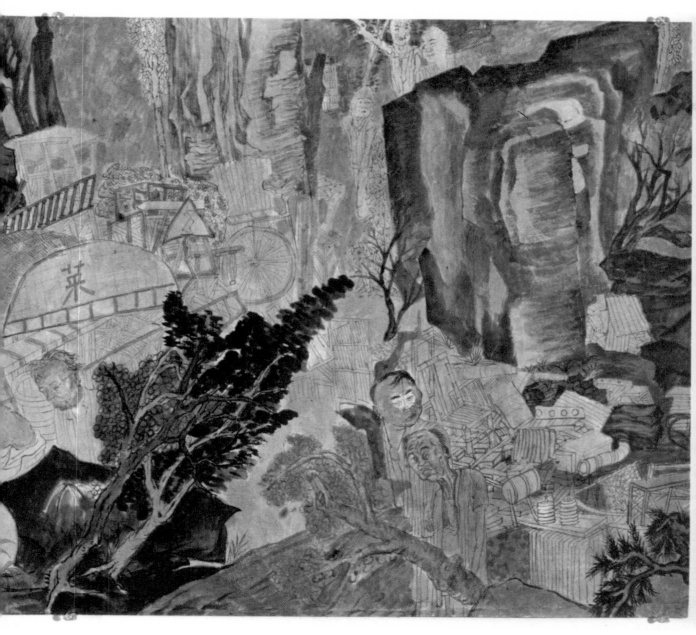

The Empty City – Listen to the Wind (2003)

MELISSA CHIU Yun-Fei, let's talk about your background and artistic training. You began your
studies at the Central Academy of Fine Arts in Beijing, one of the two most important art schools
in China, didn't you?

YUN-FEI JI Yes, but before my studies there, I had studied art at high school during the late Cultural
Revolution (1966–1976). At this time, the schools were very chaotic and classes were not really conducted
in an organized way. Students had a lot of free time. My parents wanted to keep me out of trouble, so I
had a tutor for drawing classes outside of school. He was an army officer whose job was to draw army
hand-to-hand combat illustrations. I had three art teachers before I went to the Central Academy.

MC Were you involved in the Red Guard movement?

YFJ No, I was too young. The older students were Red Guards and those who were slightly younger
were sent to the countryside (mostly to *Beidahuang*, the Great Northern Wasteland) to *shan
shen xia xiang* (meaning to go up the mountains and down to the countryside). In the early to
mid-1970s I copied drawings in the style of socialist realism — extremely positive and heroic images
of workers. These were based on the philosophy of "learning from *da zhai*," that is, the model
of the collective farm, which farmers were encouraged to emulate all over the country.

MC What subject did you major in when you attended the Central Academy? Was it painting?

YFJ I was in the oil painting department. During the first two years of study we learned the fundamen-
tals — such as drawing, sketching, proportion, and rendering. And then, in the third year, we had a choice
of study in one of three different studios. The first studio was with an artist who had studied in Europe

and whose work was influenced by European art. The second was with an artist who studied under a Soviet painter (some artists went to the Soviet Union to study painting for up to five years), and the third studio, which I chose, was with a professor named Zhan Jianjun who was known for painting heroic, historical subjects. His studio was more open to modern Western art and traditional Chinese art.

MC Yours was one of the first years when studies resumed after the Cultural Revolution. What was this environment at art school like? How would you describe it?

YFJ It was very exciting and the atmosphere was very open. We felt very special because we were the first group of students.

MC Usually we refer to the post-1979 period, after the Open Door policy, as a period when Chinese artists really looked to Western sources again (after being largely shut off from the rest of the world in 1949, the founding of the People's Republic). How would you characterize this period?

YFJ I think this was happening all over the country. All the universities were beginning to accept students and things were starting to become normal. Artists accused in the anti-right movement of the late 1950s and banished during the Cultural Revolution began to return to the schools to teach. Artists, such as Zhu Naizheng and Yuan Yunsheng, had spent time in remote places, including Tibet, for up to twenty or thirty years. They were sent to these places when they were in their twenties and they were in their forties and fifties when they came back. I feel that there was a lesson for my generation to learn from that generation of artists. When they were young, in fact my age, they were full of ideas, vision, and creative energy, but all of this was wasted because they couldn't do their work. It's also true, however, that they learned and benefited in other ways by going to these places where they wouldn't have gone otherwise.

MC What kind of impact do you think this had on your generation: to see the way that the previous generation had been treated?

YFJ I think it's a very serious lesson.

MC But would it have had an impact on the kind of art that younger artists like you were producing?

YFJ Sure.

MC Because of this, your work might have been less challenging towards political figures, is that what you're saying? By being a younger artist and seeing how a previous generation had been treated because of their work, would you say that younger artists didn't want to do anything that was critical of the government?

YFJ Oh, you mean the fear factor. Well, there was a new government, so I think that was much less the case. People felt that they could do more. But, on the other hand, when you realize the life stories of these older artists, all of whom were very talented, you learn something disturbing. I think it's not that you don't want to do political art, but under the tutelage of the party no art was possible. The only paintings we saw in exhibitions were stilted and uninteresting socialist realism paintings about the history of the revolution. Because I studied the work of these history painters I saw a whole different side to the methods behind artworks, which has influenced my work today. For example, when I start a project I spend a long time studying and researching, making notes and sketches. Sometimes the history painters would spend a month or two living in a village and working with the farmers. The sketches they brought back from these trips were great, but when they started to make the final work they had to mold them to political codes of representation. Through this process the work would evolve into a complete lie. In my own art, I follow all of the preparatory methods except this last stage. My method can be categorized as a process of collecting. Shi Tao, a seventeenth-century painter, used a seal in his paintings that says "searching a thousand strange cliffs to make a sketch." This describes a method of collecting forms from nature. You might also say that I do the same, but in relation to history. So you see, there is a strange connection between the classical landscape work and the socialist realism works.

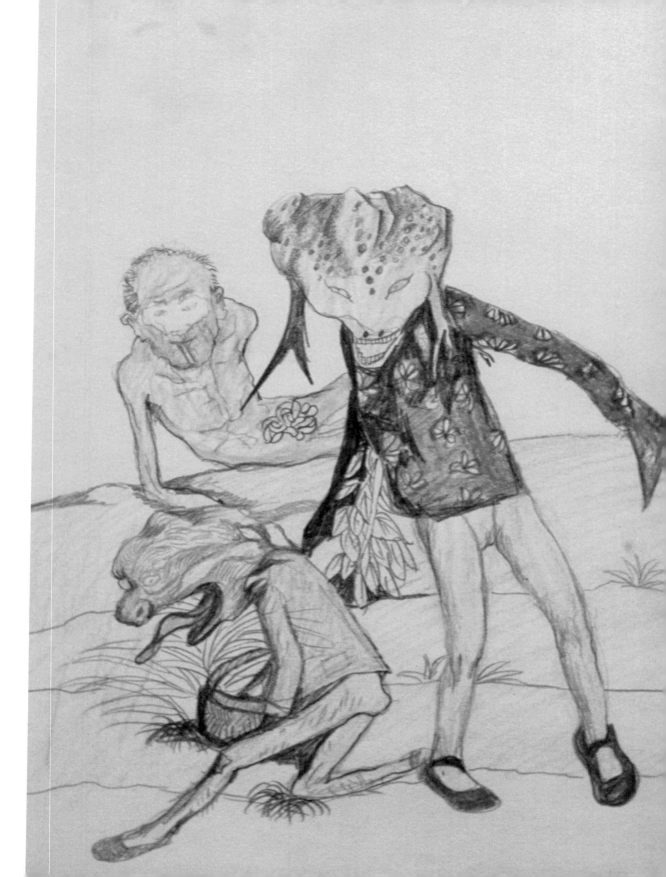

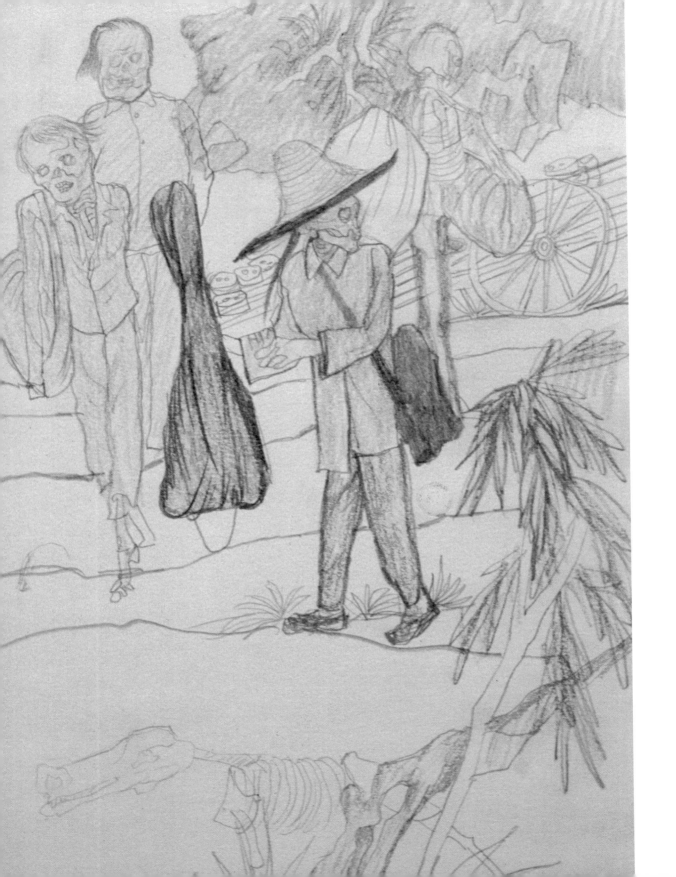

MC After four years at the Central Academy you graduated …

YFJ After I graduated, I taught at the School of Arts and Crafts in Beijing. I was very lucky to study calligraphy in my spare time with two artists. There was one artist in particular, Wang Bingfu, whom I studied calligraphy with for about three years. From this study I became more and more interested in the foundation of Chinese painting. I've always had an interest in Chinese painting.

MC But you didn't actually study ink painting at the Central Academy, did you?

YFJ No, I didn't.

MC It's curious that your works are primarily in the medium of ink now. When you left the Central Academy you were teaching and learning calligraphy. But how did you come to move to the United States? It sounds as if your career path was almost set since you had a career in teaching and as an artist. You also migrated quite early in comparison to a lot of other Chinese artists of your generation, since you left China before 1989. Wasn't it in 1986 that you went to study in the Midwest? How did you come to have that opportunity?

YFJ Well, I think it was in late 1985, early 1986, that the Anti-Spiritual Pollution Movement occurred, and I remember it started to feel claustrophobic. Before, we had this feeling that anything was possible and it was really quite open. We used to put up shows, but at that time they were being shut down.

MC That was quite common then. Wenda Gu, who is also based in New York, had exhibitions that were shut down twice during that period.

YFJ This made us think of the older times of government control and censorship. It was very uncertain. People felt that the government might revert to how it was before. And you could definitely sense that certain conservative elements in the government were starting to control the art.

MC How did you choose to go to the Midwest?

YFJ It was really by chance that I went to the Midwest. At that time I was very interested (and a lot of us were) in going to see the West. We imagined it to be much freer. We thought that we could do a lot of things and we were very curious. I took the very first opportunity to leave because it was really quite difficult to get out of China.

MC Many Chinese artists of your generation who migrated to the West spent at least the first five years just familiarizing themselves with the culture and language, often unable to make artwork. Is that how you felt as well?

YFJ Yeah, definitely. I couldn't really do much work even though I was painting. The first few years I learned English and took classes. I tried to paint but it took me a long time to adjust myself to a new culture. When I first visited New York in 1986, and then returned to live in 1990, I made sure that I went to see many museums. What really impressed me was the size of many paintings that I had seen only in books (Barnett Newman's and Jackson Pollock's paintings, for example).

MC It's curious that you talk about scale, because in many ways that has been the transition in your work that I've seen. When I first saw your paintings they were quite modestly sized, but your works produced in the past year (including those for the Contemporary Art Museum St. Louis exhibition) are of a much more ambitious scale. Can you talk about your reasons for wanting to make a bigger statement and whether you think that being here, in the United States, was an influence?

YFJ I'm sure that being here was an influence, but this large scale is also like a scroll, which is a very traditional Chinese format.

MC The traditional scroll is of a smaller scale and meant to be viewed privately with only one or two people, though.

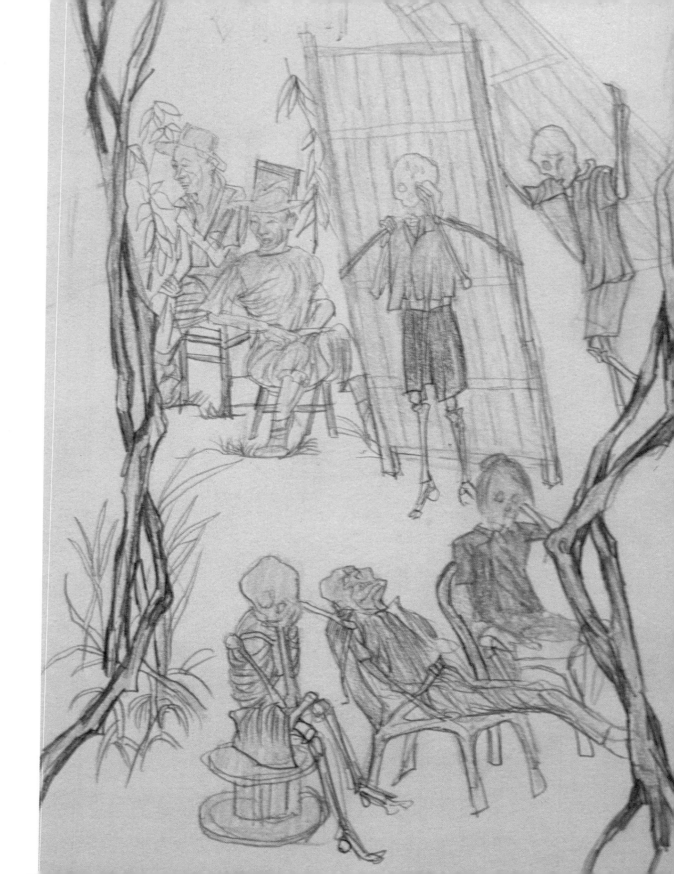

YFJ My works are bigger. The traditional hand scroll opens up gradually and is viewed by two people, holding and viewing one section at a time. In my work, I've adopted a larger scale and, with the subject, I want to be able to have room to move around. My paintings need room to develop from one scene to another scene.

MC And it's interesting that you mention scenes because, in addition to the scale changing, there has also been a move toward narrative in your recent paintings. What are some of the stories in your paintings?

YFJ My last show was titled *The Old One Hundred Names* (*lao bai xing* in Chinese— meaning ordinary people), and it had more of a focus on a community of people, so the narrative evolved around scenes such as a wedding. I am moving away from that now. I had an idea that gradually became clear to me at the end of that exhibition. I wanted to move toward the idea of an empty city.

MC It's notable that the title of your new exhibition is *The Empty City*, yet it is actually a natural environment that we see in your paintings. Maybe you can talk a bit about that: why you chose to paint a natural environment when your theme is a city?

YFJ The city in my paintings is made up of buildings that you find in a lot of Chinese cities that were built in the 1980s and '90s. But I have set the buildings into the mountains. It is all based on research from my trip two years ago to the Yangtze River to see the Three Gorges and the area where cities were being taken apart to make way for the building of the dam. In this work, I wanted to use the buildings and the changing seasons as the backdrop for a narrative about the dead and the scavengers.

MC And they are represented in the paintings by the skeleton figures?

YFJ Yes, the skeleton figures. The paintings show a small community of scavengers who live in these torn-down or empty cities and scavenge all the metal and doors. I saw these people when I was there.

MC What interested you in wanting to record these changes to the Chinese social and physical landscape? Because in many ways you've adopted a traditional approach through ink painting, yet you've included contemporary objects.

YFJ The process of recording, almost a documentary process, is very important to me. When I went to the Three Gorges, the small, everyday things were important, such as the special woven baskets. These kinds of items can tell you a lot about the context and can also suggest a sense of displacement depending on how they all relate to one another.

MC I think a lot of people don't realize that artists of your generation didn't necessarily learn Chinese art history and many, like you, have had to research it for themselves. In some ways, your work, and that of other Chinese overseas artists, can be categorized as a recovery of traditions.

YFJ I think it was Marx who said that humans had stopped developing thousands of years ago but the development of humanity is yet to begin. The Cultural Revolution had a huge impact on Chinese culture. That is what my work is all about. It is about trying to retrieve some of this history because there was so much effort to get rid of it when I was growing up. In the Great Leap Forward, we have also leaped backwards. There are two periods of great cultural destruction in Chinese history. The first was the Cultural Revolution and the second is happening right now.

MC You are speaking specifically of the The Four Olds: the reform of old habits, ideas, customs, and beliefs; this was the mantra during the Cultural Revolution.

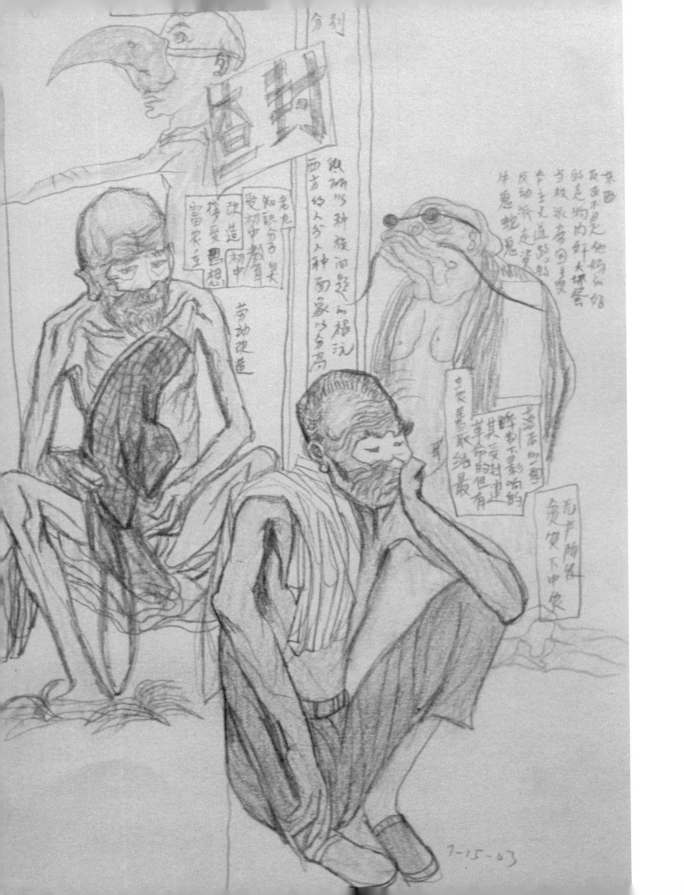

YFJ To get rid of The Four Olds was the dictum I grew up with. It was an attempt to wipe the slate
clean to make room to build a utopian society. Chinese culture is an old culture that is about
memory and history, yet the contradiction, as I grew up, was that we had to reject history in order
to start again. It is these old contradictions that I'm trying to deal with in my work. How is it that
whole cities along the Yangtze River can be destroyed? I think what's behind this thinking is
that no price is too high to wipe the slate clean. Modernization comes at a huge price. I think
Chinese people have been asked to pay a very heavy price for progress. For example, in order to
make the biggest dam in the world they had to relocate one million people.

MC What also struck me when you spoke of history painting was, on the one hand, a reference to
Chinese art history through your paintings of landscapes, while on the other hand, more recent images
from the Cultural Revolution. Can you talk about how you bring these images from different periods
together in the same narrative?

YFJ One thing that I learned from the classical tradition is a constant shifting of perspective from one
section of the painting to the next. My paintings reorganize space in a different way, shifting dramati-
cally across different periods. I think the same force of history is at work since history repeats itself.

MC I have noticed a process of erasure in your new paintings. In sections of the painting you have rubbed
out the image. This is a rather unconventional technique in a classical painting tradition, wouldn't you say?

YFJ The methods of erasure and montage (processes of subtraction and addition) applied to
collected historical material are my efforts to develop layers that work together as a whole.
When I began, I used water to wash away some of the previous images and sometimes the
paper started to deteriorate. But I wanted to keep going. Other things have become important
to me, including the mark of the brush. Each brush stroke has its own distinct character.

My calligraphic training was an influence. I learned that brushes produce many subtle textures and lines based on the amount of pressure or the dryness or the wetness of the ink. The lines all have a different quality and character. It's very nuanced, so the layers become important.

MC There is no ink tradition here in the United States, yet in recent years you have received quite a lot of recognition and have shown your work across the United States. What are some of the responses that you've had to your work since migrating to the United States?

YFJ Yes, there is no ink tradition here, but when I look at American history I can draw parallels with events that happened in China. History repeats itself in different forms and in different places around the globe. We chase one false dream after another but always come back to the same point. Painting can show us things and make connections. It creates an autonomous space for an individual point of view. It offers us a way out.

MC So what do you think your next series of works will be based on?

YFJ There is so much more that I want to create new work about. I feel like I am just beginning.

Interview recorded November 15, 2003, New York.

MELISSA CHIU is Curator of Contemporary Asian and Asian American Art at the Asia Society and Museum in New York. She was the founding director of the Asia-Australia Arts Centre (Gallery 4A) for six years, a non-profit contemporary art gallery in Sydney. Ms. Chiu has curated exhibitions over the last ten years that have included artists from Malaysia, Singapore, Vietnam, Thailand, China, and Hawaii at various galleries and museums. She has published widely on contemporary art in journals, magazines, and exhibition catalogs—such as *Third Text*, *Art and Australia*, *Orientations*, the *Journal of Australian Art*—and is a regular contributor for *Art Asia Pacific Magazine*, for which she was a guest editor in 2001 and 2003. She has recently completed a PhD on contemporary Chinese art.

All images in this section: Yun-Fei Ji, studies for *The Empty City*, from the artist's sketchbook 2002-03.

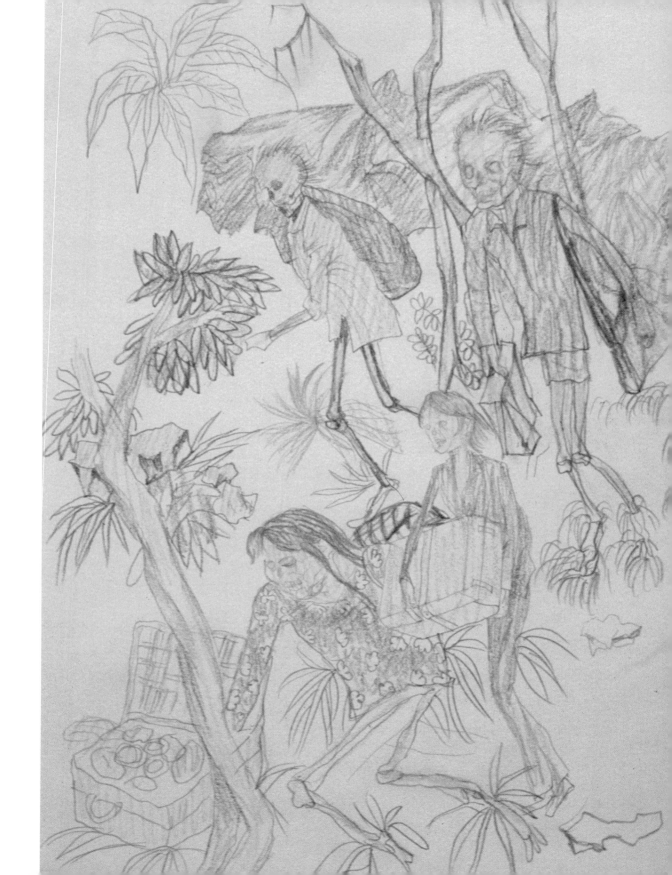

YUN-FEI JI
Born 1963, Beijing, China
Lives and works in Brooklyn, NY

EDUCATION

1989 MFA Fulbright College of Art and Sciences, University of
Arkansas, Fayetteville, AK

1982 BFA Central Academy of Fine Arts, Beijing, China

SELECTED SOLO EXHIBITIONS

2004 *Yun-Fei Ji: The Empty City*, Contemporary Art Museum
St. Louis; (traveling exhibition) Pierogi, Brooklyn, NY,
Provisions Library, GAEA Foundation, Washington, DC,
The Rose Art Museum of Brandeis University, Waltham,
MA and Richard E. Peeler Art Center, DePauw
University, Greencastle, IN

The East Wind, Institute of Contemporary Art /
University of Pennsylvania, Philadelphia, PA

2003 *The Old One Hundred Names*, ZenoX, Antwerp, Belgium
and Pratt Manhattan Gallery, New York, NY

2002 *The Boxer, the Missionary, and their Gods*, POST,
Los Angeles, CA

2001 *New Work*, Pierogi Gallery, Brooklyn, NY

SELECTED GROUP EXHIBITIONS

2004 *Regeneration: Contemporary Art from China & the US*,
two-year traveling exhibition, Bucknell University,
Lewisburg, PA

Open House: Working in Brooklyn, Brooklyn Museum of
Art, Brooklyn, NY

2003 *Thinking in Line, A Survey of Contemporary Drawing*,
University Gallery, University of Florida, Gainesville, FL

Strange Worlds, The Bertha and Karl Leubsdorf
Art Gallery at Hunter College, New York, NY

For the Record: Drawing Contemporary Life,
The Vancouver Art Gallery, Vancouver, Canada

In Heat, Pierogi, Brooklyn, NY

Rendered, Sara Meltzer Gallery, New York, NY

Breaking Away, P.S.1 Contemporary Art Center, Clock
Tower Fellowship exhibition, Long Island City, NY

Pierogi Presents, Bernard Toale Gallery, Boston, MA

*A Brush with Tradition: Chinese Tradition and
Contemporary Art*, Newark Museum, Newark, NJ

Beyond the Flâneur, ISE Cultural Foundation NY Gallery,
New York, NY

2002 *Whitney Biennial 2002*, Whitney Museum of American
Art, New York, NY

Umano Animale Vegetale Minerale, Galleria Alessandra Bonomo, Rome, Italy

Fantasyland, D'Amelio Terras, New York, NY

Strolling Through an Ancient Shrine and Garden, ACME Gallery, Los Angeles, CA

Selection 1; Made in Brooklyn, Wythe Studio, Brooklyn, NY

Faux Real, Borusan Art & Culture, Istanbul, Turkey

PROJECT 3, Elga Wimmer Gallery, New York, NY

Altoid's Curiously Strong Collection, New Museum for Contemporary Art, New York, NY

Fellow's Exhibition, Art Association, Provincetown, RI

2001 *Best of the Season, Selected Work from the 2000–01 Manhattan Exhibition Season*, The Aldrich Museum of Contemporary Art, Ridgefield, CT

ArtForum Berlin 2001, work exhibited by Pierogi, Berlin, Germany

Brooklyn!, Palm Beach Institute of Contemporary Art, Palm Beach, FL

Selection, The Drawing Center, New York, NY

2000 *The Meat Market Art Fair*, Pierogi, New York, NY

The Old News, P.S. 122 Gallery, New York, NY

Haulin' Ass: Pierogi in L.A., POST, Los Angeles, CA

Multiple Sensations, Yerba Buena Center for The Arts, San Francisco, CA

Super Duper New York, Pierogi, Brooklyn, NY

1999 *Sensation*, Richard Anderson Gallery, New York, NY

Faculty Show, Lemmerman Gallery, Jersey City, NJ

1998 *Yun-Fei Ji, Andrea Dezso, Randy Wray*, Jack Tilton Gallery, New York, NY

1997 *Fermented*, Parsons School of Design, New York, NY

Relocating Landscape – East and West, Caldwell College, Caldwell, NJ

Artist in the Marketplace Program, The Bronx Museum, New York, NY

Travel-Sized, City College, New York, NY

Reflecting Pool, Kenkeleban Gallery, New York, NY

Twelve Cicadas in the Tree of Knowledge, Asian American Arts Center, New York, NY

1996 *Immigrant Artists from East and West*, ONETWENTY-EIGHT Gallery, New York, NY

1993 *Recent Paintings*, Meredith Long Gallery, Houston, TX

1990 *Introduction*, Meredith Long Gallery, Houston, TX

CHECKLIST

Bon Voyage, 2002, 77 x 26 1/2 inches, ink and mineral pigment on mulberry paper,
Collection of Peter Norton, Santa Monica, California

The Empty City – Fragrant Creek, 2003, 37 3/4 x 59 inches, ink and Chinese watercolor on *xuan* paper,
Courtesy of the artist and Pierogi, Brooklyn

The Empty City – Listen to the Wind, 2003, 25 x 116 3/4 inches, ink and Chinese watercolor on *xuan* paper,
Courtesy of the artist and Pierogi, Brooklyn

The Empty City – East Wind, 2003, 35 1/2 x 53 1/2 inches, ink and Chinese watercolor on *xuan* paper,
Courtesy of the artist and Pierogi, Brooklyn

The Empty City – The Autumn Colors, 2003, 32 1/2 x 92 1/2 inches, ink and Chinese watercolor on *xuan* paper,
Courtesy of the artist and Pierogi, Brooklyn

The Empty City – Calling the Dead, 2003, 19 x 185 inches, ink and Chinese watercolor on *xuan* paper,
Courtesy of the artist and Pierogi, Brooklyn

CREDITS

Dinner at the Forbidden City, Private Collection

The Boxer, the Missionary, and their Gods, Private Collection

Rebellion of the Singing Girls, Private Collection

Nixon in China, Private Collection

A Monk's Meditation on a Woman's Vagina being Interrupted, 2001; Mineral pigment on rice paper, Overall: 19 x 108in. (48.3 x 274.3cm); Framed: 108 1/2 x 24 1/8 x 2in. (275.6 x 61.3 x 5.1cm); Whitney Museum of American Art, New York; purchase, with funds from the Drawing Committee 2002.146

The Garden of Double Happiness, Collection of Ninah and Michael Lynne

Hanging Garden, Altoid's Curiously Strong Collection, New Museum of Contemporary Art, NY

The Picnic, James Keith Brown and Eric Diefenbach, NY

Mishaps 2, Private Collection

Passage, Collection of Chris and Christine Peddy